WITHDRAWN

Discover the Joy of Acrylic Painting

DISCOVER

the

Joy

of Acrylic Painting

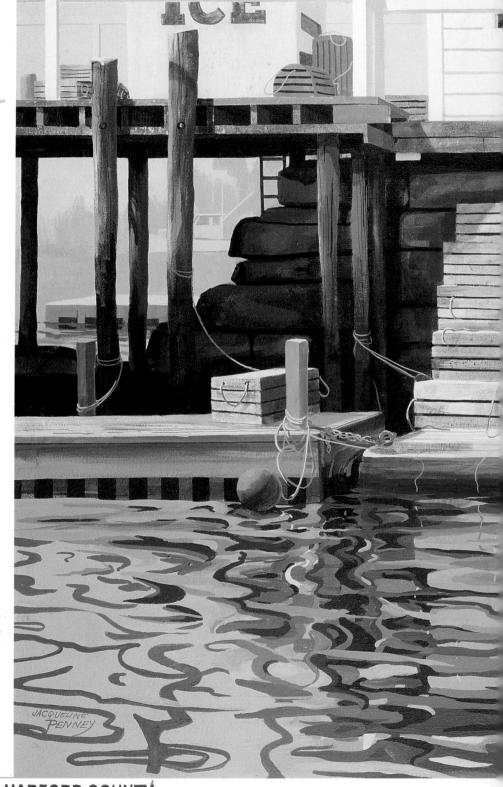

NORTH LIGHT BOOKS
CINCINNATI, OHIO

www.nlbooks.com

JACQUELINE PENNEY

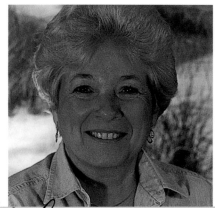

ABOUT THE *Author*

JACQUELINE PENNEY is a native of Long Island. She won a scholarship to the Phoenix School of Design in New York City, where she received an excellent background in drawing and anatomy. After attending Black Mountain College in North Carolina and the Institute of Design in Chicago, she continues her art education by studying with well-known artists around the country. She is in *Who's Who of American Women/Teachers*, is affiliated with several national organizations, and is widely published. Seventy-eight of her paintings have been reproduced by Aaron Ashley, Inc., of New York.

Penney is best known for her realistic pastoral scenes, predominantly painting with acrylics; however, she is adept in several other mediums. Her first book with North Light, *Painting Greeting Cards in Watercolor*, is a how-to book about painting "little watercolor gems" at home or on the go.

Discover the Joy of Acrylic Painting. Copyright © 2002 by Jacqueline Penney. Manufactured in China. All rights reserved. No part of this book may be reproduced in any form or by any electronic or mechanical means including information storage and retrieval systems without permission in writing from the publisher, except by a reviewer, who may quote brief passages in a review. Published by North Light Books, an imprint of F&W Publications, Inc., 1507 Dana Avenue, Cincinnati, Ohio 45207. (800) 289-0963. First edition.

Other fine North Light Books are available from your local bookstore, art supply store or direct from the publisher.
06 05 04 03 02 5 4 3 2
Library of Congress Cataloging-in-Publication Data

Penney, Jacqueline
Discover the joy of acrylic painting / by Jacqueline Penney.
p .cm.
Includes index.
ISBN 1-58180-042-8 (hc. : alk. paper)
1. Acrylic painting--Technique. I. Title.
ND1535 .P46 2001
751.4'26--dc21
00-049627

Edited by Marilyn Daiker
Production edited by Nancy Pfister Lytle
Cover designed by Lisa Buchanan
Interior designed by Stephanie Strang
Interior layout by Kathy Bergstrom
Production coordinated by John Peavler

DEDICATION

I dedicate this book to Sandra Forman,

who encouraged me, believed in me and was the first to call me artist.

Acknowledgments

I'd like to thank all of the people who worked on this book, without whose help it wouldn't have been possible: Rachel Wolf, Marilyn Daiker, Nancy Pfister Lytle, Stephanie Strang, Lisa Buchanan and John Peavler.

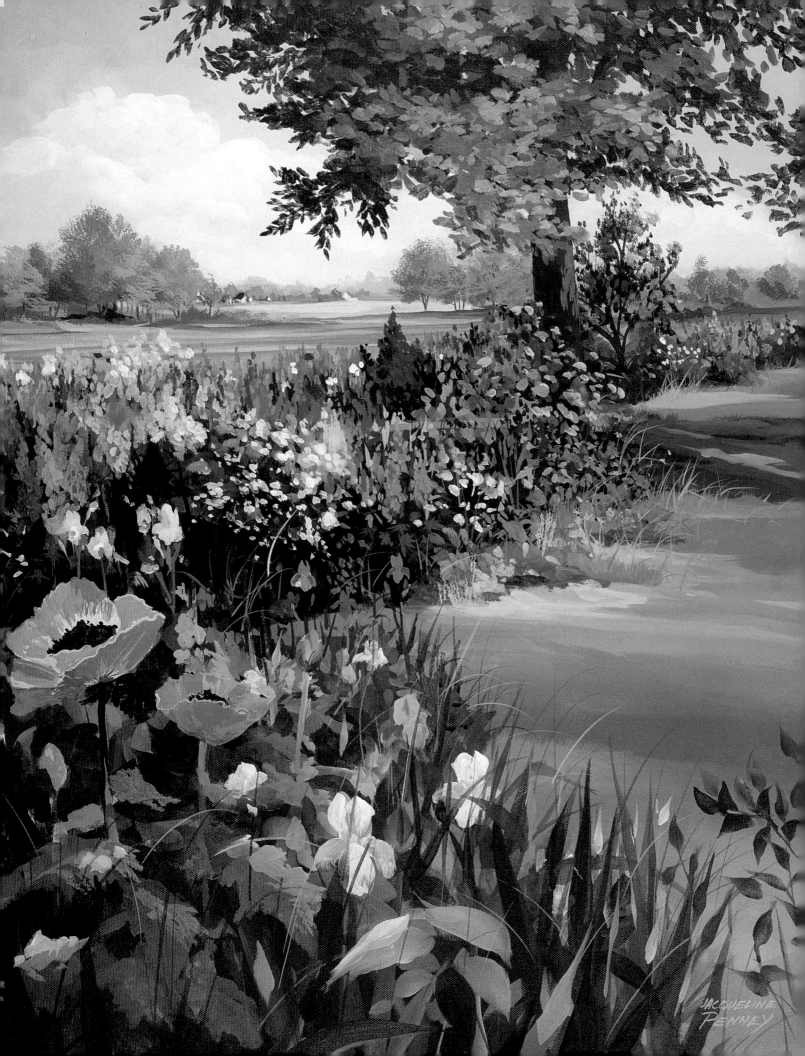

TABLE OF
Contents

PLACE OF INSPIRATION

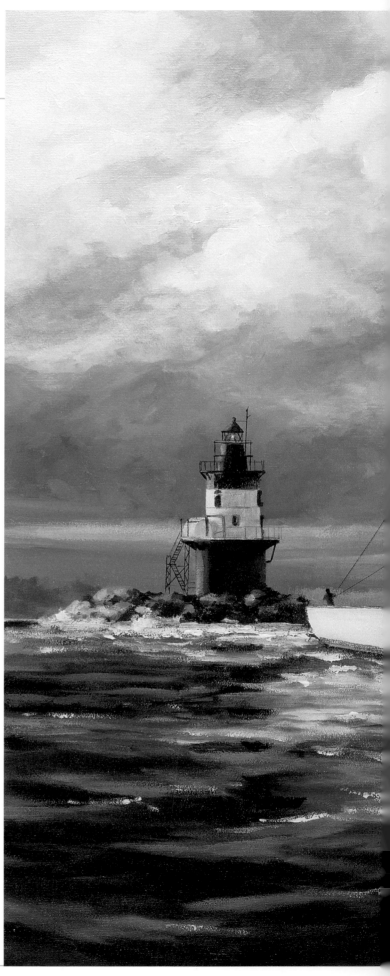

i am a native of Long Island, New York, and have spent most of my life near the water—Long Island Sound on one side and the Atlantic Ocean on the other. The island is long, approximately 120 miles, connecting with New York City via bridge and tunnel to the west. The East End, where I live, is still quite rural and has acres of farmland and vineyards on which to feast the eye. Along the whole South Fork of the island are magnificent sandy beaches, grass-covered dunes, inlets and the restless Atlantic Ocean. The North Fork has Long Island Sound to the north, and on clear days you can see Connecticut. Peconic Bay, known for its scallops, separates the two forks, with pristine Robin's Island and sparsely inhabited Shelter Island in its midst, the latter accessed by ferries that connect the two eastern tips of the island, Montauk and Orient Points. A few farms still spread from the main road to the water, affording vistas of magnificent beauty. Inlets and marshlands lace themselves to the land and abound with wildlife: flora and fauna. I draw inspiration from this place of farms and waterways to create many of my pastoral scenes.

The flatlands seem to go on forever, with soft billowing clouds that hold moisture above the everchanging marshlands, shallow water that gradually deepens to allow sailboats to tickle its surface and gentle breezes that set the grasses into motion. So many days to remember in my mind's eye, no two the same, and I find it amazing how one place can take on a moving picture-like quality, inviting me to stay until the end of the show, except it never ends. I continually draw upon this everchanging landscape for inspiration, gathering clouds from one location and placing them over another, maybe over a spit of land that is surrounded by water or a farm field and an old house barely visible in the mist, sometimes fitting the pieces together like a jig-saw puzzle. I always have my little pocket camera in the car to record what I see for future use.

CLOSE COMPANY 22" x 28" (56cm x 71cm), oil over acrylic, collection of the artist, print available from Aaron Ashley, Inc.

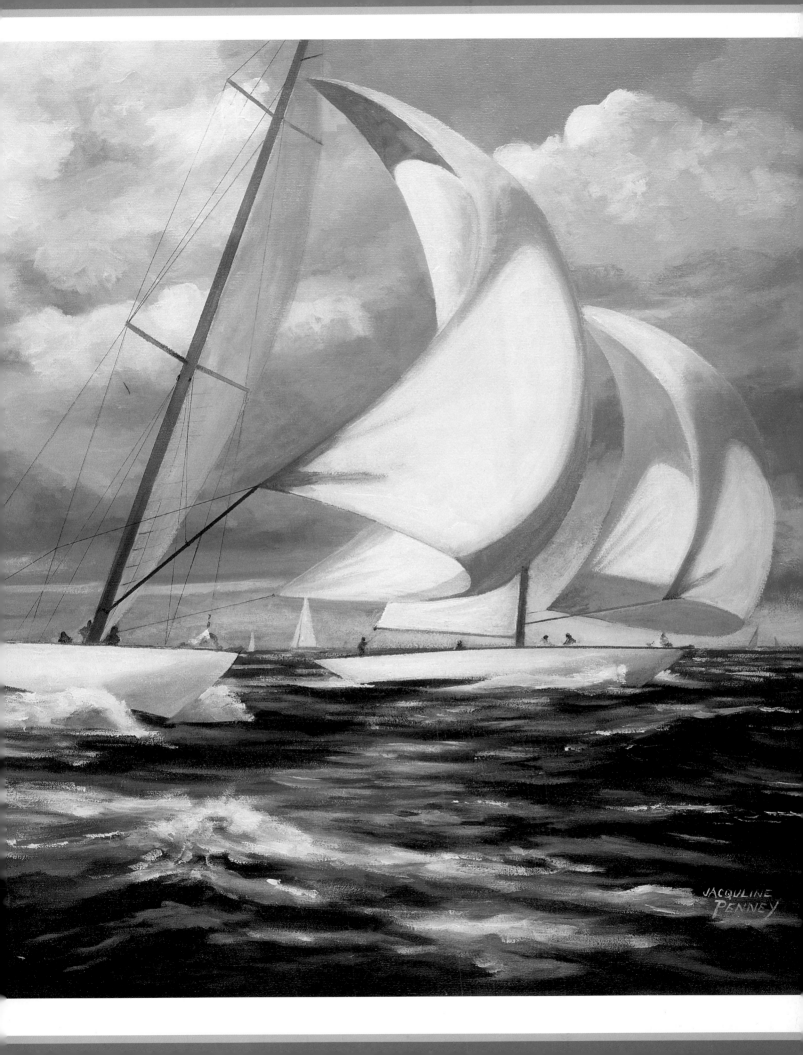

DIFFERENT AND DISTANT PLACES

Travel offers different vistas and subjects that challenge my expertise and stir my artistic core into action. My flatland origin makes being in the mountains a thrilling experience and has a profound effect on me, not only physically but also emotionally. I was artist in residence for two years in Yosemite National Park and was overcome by the beauty and grandeur of this majestic place.

More recently, a trip to the Forbes Trinchera Ranch in the Colorado mountains not only provided me with new and exciting vistas but also afforded me a week of luxurious plein air painting, and that wonderful experience is ingrained in my memory. Painting in a foreign land is another stimulus, and the culture, architecture and landscape inspire me to record what I see and express what I feel in my art journal.

LET ME INFLUENCE YOU

If you want to learn how to paint, I hope to inspire you to use acrylic paints because it is a perfect medium for the beginner. If you already paint with another medium, hopefully the variety of techniques I demonstrate in this book will impress and influence you enough that you will want to try painting with acrylics and you can judge the medium for yourself.

LEARN TO LOVE WHAT YOU HATE

I was adept in oil painting long before I fell in love with acrylics. I admit freely that I didn't succumb easily to using this new medium, but when it became a matter of health, I had no choice. Then, like the kid who goes kicking and screaming to a party and discovers it's the best ever, I complained and moaned about how awful this new medium was—until the day I stopped comparing it to oils. That was the day I discovered the uniqueness of this wonderful medium, and I haven't stopped lauding it since then.

FAST-DRYING OIL PAINT

I subscribe to several art magazines and love to read artists' captions illustrating their demonstrations. The oil painter will describe the use of certain colors and then say, "I allow it to dry and proceed with, etc." Well, I know how long oil takes to dry, especially when using a tinted mixture for a sky. I can't wait that long to get on to the next phase—I lose interest—but guess what? I still use oil paints occasionally. Technological improvements have made oil painting more user friendly, and I make use of what they offer me, namely, blending and glazing. There are now fast-drying oils and even water-soluble oils on the market. Some subject matter, such as water, is enhanced when I use oils to blend or glaze, but only when the major part of my painting is complete. At that stage I am not anxious or concerned about how long it will take to dry. I have talked to artists and paint manufacturers, and their opinions about combining the two mediums are almost equally divided. Time will have to be the judge, because the jury is still out.

FAST VERSUS SLOW DRYING

When I was artist in residence at an art association in Florida for three months, I was expected to teach all media, which I did. The oil artists and acrylic artists shared the same class, and there was constant dialog about which medium was the best. I proposed that I demonstrate the same subject and technique using acrylics for one and oils for the other and they could decide for themselves. As I recall, it was a simple floral still life, and I chose to use a combination of brush and palette knife. When the two paintings were completed, I set them aside to dry while we had lunch. When I displayed them again I asked everyone to tell me which was the acrylic and which was the oil. I think they had to guess because the paintings really looked alike, and the only way they could be sure was to go up and touch them: Obviously the acrylic painting was dry and the oil was wet. I sold both of them to different students, and I would wager that the thickly painted oil took six months to dry.

PLAYING AND EXPERIMENTING

Sometimes a brush just doesn't achieve the effect I want so I use a toothbrush to spatter sand texture or a sponge to create lichen on rocks. Playing with tools and equipment is what keeps me interested and charges my creative battery. Each brush serves a purpose, and the adventuresome artist discovers more than one use for any utensil. Think of holding a brush in a different way, using an edge or stroking, spattering or splaying it open on purpose to use only the very tip of the bristles to create grass, fur or hair. Paint can be applied in many ways—it can be used very dry, very wet, very thick or mixed with other mediums to extend or thicken it. The idea is to have fun experimenting: The process is far more important in the long run than the product.

DIFFERENCES

If you wish to compare acrylic painting and oil painting, there are only two differences that you may think are disadvantages.

1 *Fast drying*
2 *Wet pigment dries a little darker*

Let me list the advantages.

1 *Fast drying*
2 *Quick adjustments and alterations*
3 *No wet areas to smudge*
4 *Immediate glazing and varnishing*
5 *Doesn't yellow with age*
6 *Easy cleanup*
7 *Will not crack*
8 *Masking is possible*
9 *No odor or fumes*

In my opinion, acrylic paint has its own unique qualities, stands on its own as a fine art painting medium and should not be compared to oils. The variety of expression it affords the artist is remarkable, and my thirty-five years of experience with this medium allow me the right to give it rave reviews.

Today's technology offers the artist more tools with which to work, not just avant-garde painting materials for the twenty-first century, but also projectors, copy machines, computers, color printers and graphic programs to broaden creativity. I offer suggestions about how to use this technology throughout this book.

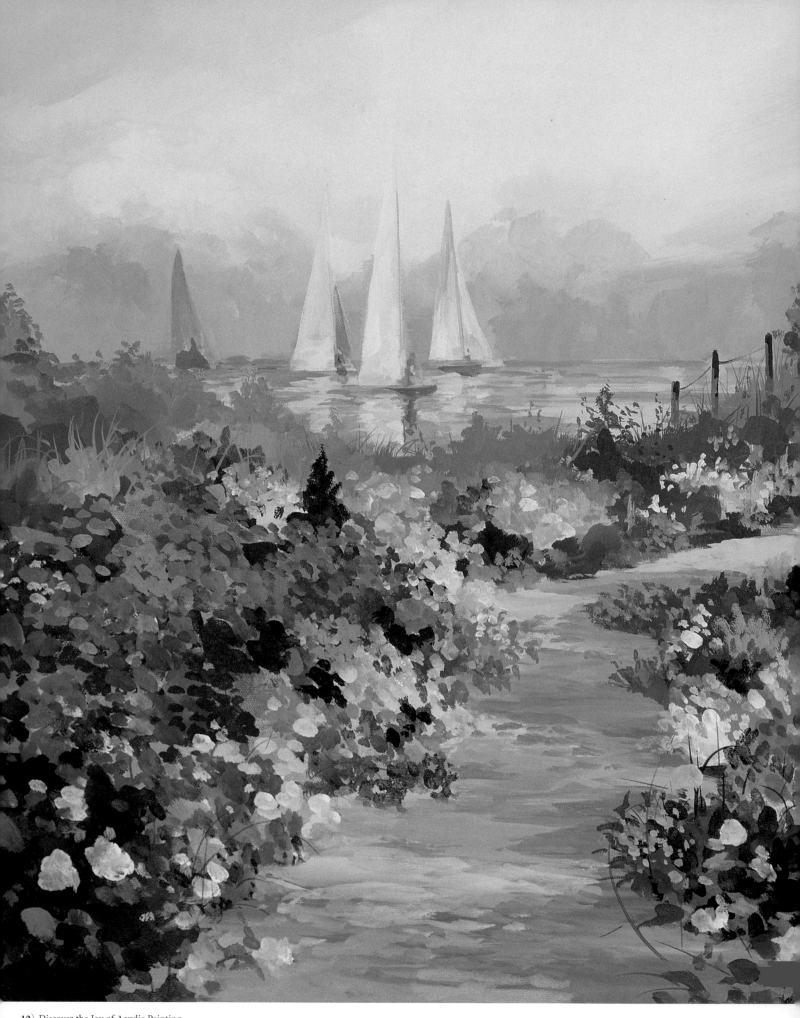

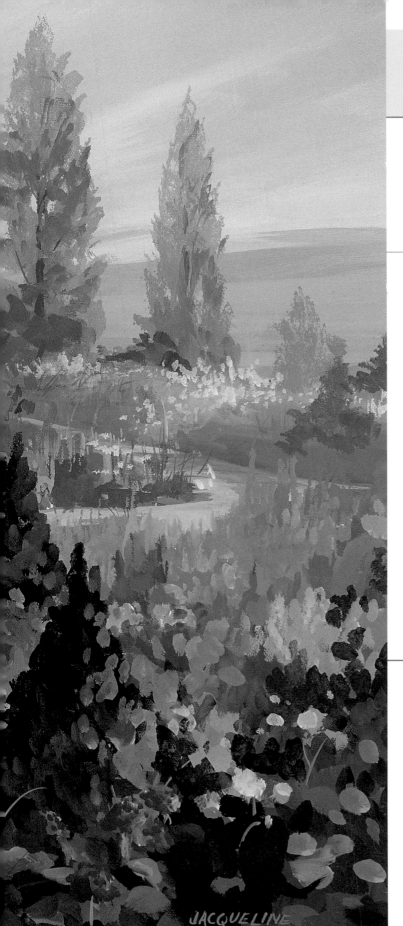

how to get (and stay) happily prepared to paint

TEACHABLE SKILLS

Painting techniques are nothing more than skills, and these skills are commensurate with printing or writing in longhand, the teachable skills we learned in grammar school. Creativity is usually motivated by a yearning for something different, to expand one's horizons or, to access a place deep within that needs to be fulfilled. That does not mean that it will be easy or that it will come without some, and sometimes considerable, effort and risk. Interest and talent are not synonymous, but many people think of them as such. Interest means curiosity, appeal, fascination and engrossment. Talent means ability, aptitude, gift and genius. Frequently, people who yearn to paint claim, "I have no talent." Even though they would like to paint, they become discouraged after a few attempts, exclaiming, "You see, I told you I have no talent." Is it because they really don't have the interest? Or is it because they don't want to make the commitment after realizing their fascination requires a great deal of time and effort?

AFTER GLOW
22" x 28" (56cm x 71cm), acrylic on canvas, collection of the artist, print available from Aaron Ashley, Inc.

PREPARING THE PALETTE

efore I begin to paint, my palette is always laid out with a full range of colors from which to choose. I don't want to go around opening tubes or jars to add a color I forgot to put out. There are many manufacturers of fine acrylic paints, and acrylic paints are available in plastic jars and tubes of various kinds and sizes. I have used most of them and find that they are all acceptable paint media with only minor differences. My personal preference is Liquitex, primarily because it was the first company, as I recall, to market jar paints, and I liked their smooth viscosity.

My preferred palette is an old white enamel butcher's tray that I found at a garage sale. It is very easy to clean. Newly manufactured enamel trays can be ordered or purchased at art stores, and in a pinch you can use a large white platter, a dinner plate or a disposable palette sold in art stores.

I place my pigment on damp paper towels positioned around the edge of my palette. This helps keep the paints moist and usable for weeks. To store the paints I cover the tray with a piece of plastic wrap and slide it into a plastic bag, folding the ends under the tray to seal the moisture inside.

KEEPING ACRYLICS USABLE FOR WEEKS

tip

You do not have to use the exact colors that I have on my palette. However, I suggest that you purchase a warm and cool color of each of the primaries (red, yellow and blue) and one of each of the secondaries (orange, green and violet) plus white. A wish list of other colors is good to give your friends and family for gift ideas.

1) *Fold the Paper Towel*

Use a sturdy brand of paper towel and fold it three times into a long strip. Then make it smaller by folding it twice again in the other direction. This makes it easier to handle.

2) *Wet the Towel*

Submerge the folded paper towel in water and squeeze the excess water out so that the towel is just damp, not wringing wet. You might want to squeeze it between your palms so that it doesn't get wrinkled.

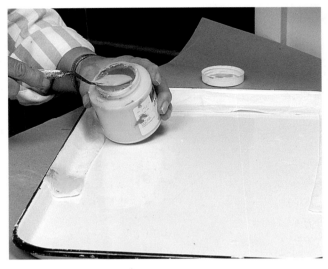

3) *Finish the Palette*

Open the last two folds and place the elongated strip along the inside edge of your tray. Repeat until you have at least three inside edges of your palette covered with the damp paper towels.

4) *Add Color*

Squeeze paint from the tube, or load a good amount of pigment onto the damp towel with a palette knife if you are using jar paints, starting with the lightest hue, Cadmium Yellow Light.

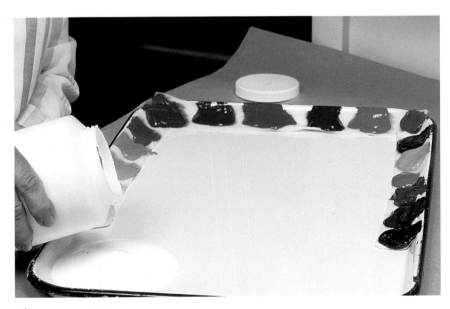

> ***tip**
>
> Chromacolour, a Canadian-based company, makes a Masterson Sta-Wet palette that has a tight lid, a wet sponge that provides a constant source of moisture and special permeable paper that keeps the paints workable for a long time.

5) *Arrange Colors*

Continue adding colors to your palette in a counterclockwise direction. I like the white and mixing area to my right because I am righthanded; "lefties" might like it the other way around.

Cadmium Yellow Medium	Yellow Orange Azo
Cadmium Orange	Cadmium Red Light
Naphthol Crimson	Acra Violet
Dioxazine Purple	Ultramarine Blue
Cobalt Blue	Cerulean Blue
Phthalocyanine Blue	Permanent Green
Phthalocyanine Green	Yellow Ochre
Raw Sienna	Burnt Sienna
Raw Umber	Burnt Umber
Payne's Gray or Black	Titanium White

I place a large quantity of Titanium White in the right corner near the yellow.

6) Clean Up

For a quick and easy cleanup when you are finished painting, load a paper towel with water and slosh it over the paint in the mixing area. Wait about thirty seconds or so and gather up the wrinkled paint that has formed on the surface with the wet towel. Clean the mixing area thoroughly with a dry towel.

7) Store Your Paints

To store the paints, place two wet sponges one on top of the other in the middle of your tray. This will hold the plastic wrap above the paints. Place plastic wrap over the tray and press it down around the edges. If your palette is large it may take two strips of plastic wrap to cover it entirely. To keep the paints from getting moldy, pour a little vinegar on the sponges. If you do not plan to paint for a while, place your plastic-wrapped palette in a small plastic garbage bag. Another suggestion is to put your paints in the refrigerator if you have room.

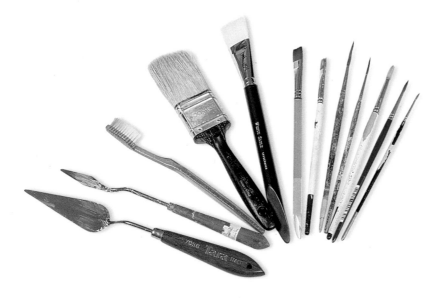

PAINTING UTENSILS

The painting utensils I use most are (shown left to right):

- *medium and small palette knives*
- *toothbrush*
- *"Yachtsman" 1½-inch (38mm) bristle brush (purchased in a hardware store)*
- *1-inch (25mm) Robert Simmons square-tip skyscraper (the brush I use the most)*
- *½-inch (12mm) and ¼-inch (6mm) square-tip brushes*
- *rigger brushes (no. 6, no. 4 and no. 2)*
- *medium and small round-tip brushes for details*

PAINTING GROUNDS AND SUPPORTS

ALMOST ANYTHING GOES

*a*crylic paint lends itself to almost any support imaginable with one exception—oily surfaces. I demonstrate my techniques on canvas, illustration board, Luan plywood and prepared Ampersand Gessobord.

Even more interesting, a question was answered about the debate whether to use hardboard (or Masonite) that is tempered or untempered as an art substrate. According to Ralph Mayer, who wrote *The Artist's Handbook of Materials & Techniques* (originally published in 1940), "tempered Masonite should be avoided for use in gesso panels, as adhesion with such an oily base as well as the permanence of the oily material itself is doubtful."

Today, the manufacturing process, as well as the meaning of tempering, has changed. *Tempered board* now simply refers to the superior physical characteristics of the board, not the oil used in the original process. Ampersand, based on this research, has come to the conclusion that, while both tempered and untempered boards can be used successfully as a painting substrate, the tempered board is superior because of its additional strength and durability.

ARE YOU CRAFTY?

For the craft artist there is no end of use for acrylic paint. I don't always paint on flat surfaces. When my children were small, we spent hours on the beach, where I collected small stones. I glued them together with epoxy cement to make chess pieces. I hand-painted the pieces using Liquitex paint and, when they dried, sprayed them with clear varnish to protect them. To make them stand upright, I put a large dab of epoxy on the bases and placed them on wax paper to dry. The epoxy doesn't stick to wax paper and gives each piece a flat bottom.

I also collaborated with a friend to make a chess set out of wooden beads.

He connected the beads by inserting and gluing wooden dowels into the holes, and then used epoxy to glue metal washers to the bases. The chessboard was made of magnetic material so that the chessmen stayed in place even when the table was tilted. I had a wonderful time painting the chess pieces.

As a donation for a local fundraiser, the sixth Chair-ity Auction to benefit Hospice, I painted a child's chair. I primed the chair and painted it with acrylic paints, using drafting tape to make the checkerboard design on the seat, similar to the technique I use in chapter 3, project 1–*Billowing Clouds* (see pages 44-49), making crisp straight lines on the lighthouse. Then, I hand painted the ants, bees, ladybugs and foliage. A final coat of clear water-based varnish protects the artwork.

You do not have to limit yourself: You can paint on almost everything except a surface that is oily or too slick.

Child's Chair

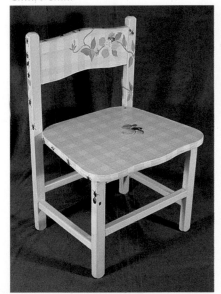

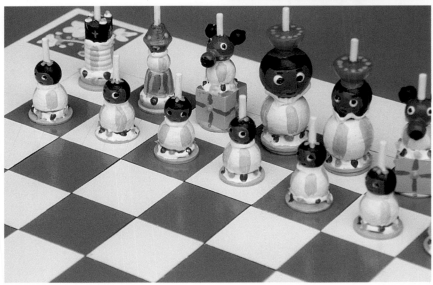

Painted Beads Chess Set

SUPPORT PREPARATION

CANVAS

*t*he most commonly used support is canvas, which is made from cotton, linen, jute or synthetic fibers. It may be purchased by the yard or in large rolls that come in several weights and sizes. Canvas can be purchased primed or unprimed. I demonstrate on both pre-stretched primed cotton canvas and canvas that I stretch and prime myself. Project 4 in chapter 3 (*Reflections* on page 61) is done on canvas that I stretched and primed on regular stretchers. Project 3 in chapter 4 (*Monday* on page 83) is done on canvas that I also stretched and primed, but on heavy-duty stretchers to prevent warping because of its size.

Many artists purchase prestretched canvases from art stores, eliminating a lot of time and energy. However, if you wish to experiment with different kinds of canvas you may find it difficult to find them already stretched. For large works and odd sizes, I prefer to stretch my own canvas on heavy-duty stretcher bars. I wrap the canvas around the edges and staple it to the back of the stretchers. I paint the edges while painting the scene, giving the buyer the option of framing it or not.

AMPERSAND GESSOBORD

Ampersand Gessobord can be purchased or ordered from national suppliers and art supply stores. In chapter 5 I illustrate an interesting technique using watered-down acrylic paint on Gessobord. I cover it with plastic wrap and allow it to dry, achieving an unusual textured pattern as an underpainting. The ultrasmooth surface of Gessobord differs from textured supports, and it has a totally different feel to it. It comes in several thicknesses ($\frac{1}{8}$", $\frac{3}{16}$" and $\frac{1}{4}$") and the sizes range from 5" x 7" (13cm x 18cm) to 24" x 36" (61cm x 91cm). The panels are available with "cradling" [supported with 1" (2.54) wood strips along the back of the board and flush with the edges]. Larger panels can be special ordered and delivered.

WATERCOLOR PAPERS

I prefer Arches 140-lb. (300gsm) and 300-lb. (640 gsm) cold-pressed watercolor paper; however, any brand will do. To prevent curling, some artists prefer to seal the back of the paper with matte or gloss medium.

ILLUSTRATION BOARD

There are many kinds of illustration board from which to choose, and I particularly like Crescent watercolor board. There are three different surfaces: rough, cold pressed and hot pressed. I prefer to paint the back of the board with matte or gloss medium to prevent warping.

LUAN WOOD PANEL PREPARATION

Luan is thin plywood that has a fine grain on one side and is slightly rough on the other. It may be purchased in 4' x 8' panels from a lumber supply company.

1 It is imperative to be exact when measuring and cutting the large panel into smaller ones: Distorted panels make framing very difficult. Whatever the size of your panel, the preparation is the same. The panel and all edges must be sealed to prevent expansion from moisture. If you have several panels to prepare, I suggest doing them all at once.

2 Sand the panel with medium/fine grit sandpaper, by hand or with an electric sander. Dust the surface off and apply one coat of either wood primer or clear water-based varnish with a large brush using smooth, even brushstrokes, painting the edges as well. Drying time will depend on the humidity.

3 When dry, sand the surface again with medium/fine grit sandpaper, turn the panel over to the rough side, and repeat the process.

4 When dry, turn the panel back to the smooth side and apply two coats of gesso. You can use a paint roller (marked "smooth") and a paint pan that house painters use. Dilute the gesso with a little water before pouring it into the pan or applying it with a brush. Use at least a 3" (8cm) wide flat brush with natural bristles. Apply gesso in a thin layer from left to right only and allow it to dry thoroughly.

5 When dry, sand until smooth. Wipe clean and apply a heavier coat of gesso. Roll or brush the gesso in the opposite direction. Allow it to dry and sand again. You may repeat this process until you have found the surface you desire. For sealing purposes, only two to three good coats of gesso are needed.

MASONITE AND/OR HARDBOARD PREPARATION

Masonite and/or hardboard can be purchased at a lumber supply store. You will need a paintbrush (at least a 3-inch wide flat brush with natural bristles), gesso of your choice, water and a light grade sandpaper.

1 Lightly sand the hardboard to roughen the surface for better adhesion of gesso to the panel.

2 Thin acrylic gesso with up to one-third water for the first priming so that the gesso can flow more easily onto the panel.

3 Apply the gesso in a thin layer from left to right only and allow it to dry thoroughly.

4 Sand until smooth.

5 Repeat steps 3 and 4. However, apply a heavier coat of gesso and in the opposite direction, allow to dry and sand again. You may repeat this process until you have found the surface you desire.

This photo of the primed smooth side of the ⅜" (0.95cm) Luan wood panel overlaps the underside to show the wood texture.

learn the basics

Flowers display their splendor in our gardens for a short time during the warm months, and when the cold winds of winter come my need for a promise of spring emerges and becomes an incredible craving; I want to paint those flowers that are now dormant.

I have two double file boxes of 4" x 6" (10cm x 15cm) photographs under headings such as "Landscapes," "Gardens," "Boats," "Clouds," "Trees" and "Water Scenes," and one of my largest collections of photos is under the heading "Flowers," categorized under specific kinds. Next to the print files I keep another file for slides, also categorized by subject, so that if I need references I have two sources from which to choose.

This chapter introduces you to tools and techniques that will include cast shadows and the use of photographs, slides, projectors, copy machines, tracing paper and transfer paper. Demonstrations will include stippling, blending, glazing, masking and wet-in-wet techniques, emphasizing the versatility of the acrylic medium.

The first projects describe three different ways to paint flower portraits on an elongated vertical format with cast shadows, using the white of the canvas as a background. Later we make use of a projector to enlarge a portrait of a lily onto a colorful background that was painted first with a wet-in-wet technique and allowed to dry.

Let me show you how to use this versatile medium and, when you realize that you can paint continuously and never have to wait for an area to dry, I believe you will celebrate its fast-drying quality as I do. The mini demonstrations concentrate on color, value and techniques. Completed paintings illustrate how these techniques are used to create cheerful scenes, with callouts bringing your attention to composition.

PORTRAIT OF A LILY
22" x 28" (56cm x 71cm), acrylic on canvas

SIMPLE FLOWER PORTRAITS

PROJECT 1) a simple tulip

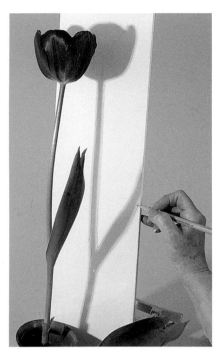

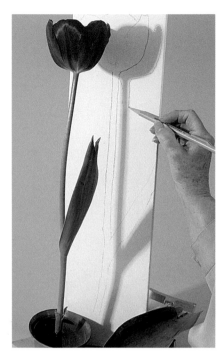

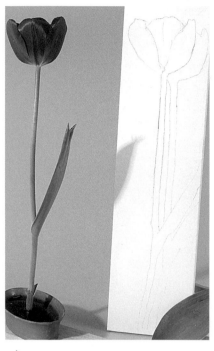

1) *Draw Silhouette*

Shine a regular lamp on a single tulip that is placed in front of a 5" x 20" (13cm x51cm) canvas so that its shadow is cast onto the middle of the canvas. Trace the outline of the shadow onto the canvas. This creates a silhouette drawing of the tulip. Refer to the real tulip and draw the two lines that separate the front petals to complete the drawing.

Photo by Mike Richter

2) *Duplicate the Shadow*

Move the lamp slightly so the shadow projected on the canvas is slightly lower and to the right of the first tracing. Trace the second outline carefully onto the canvas. This creates the shadow of the tulip.

Photo by Mike Richter

3) *Get Two for One*

Now you have a drawing of a tulip as well as its shadow drawn on your canvas and you are ready to paint. I recommend this technique for artists who are more interested in painting than in drawing.

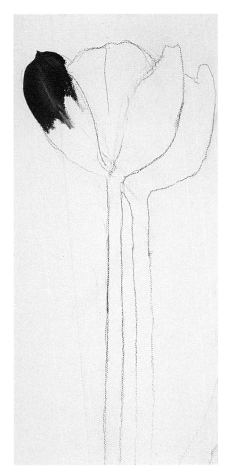

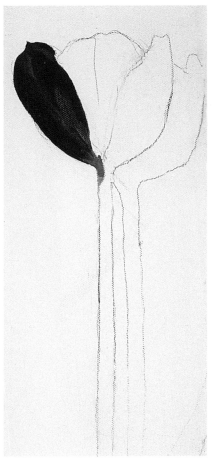

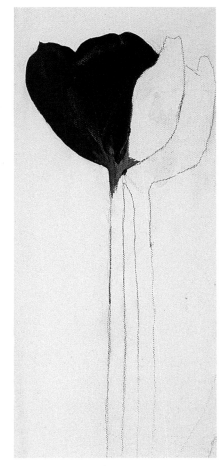

4) *Paint and Blend*

In this small area of the petal, use Cadmium Red, Alizarin Crimson and Cadmium Yellow, blending the colors as you paint.

5) *Create a Transition*

The light source is from the upper left, so the left side of the tulip is light, but it becomes a little duller on the lower portion where the light isn't as intense. Blend a combination of yellow/green—Yellow Ochre and Permanent Sap Green—into the red mixture for a smooth transition from red to the greenish hue near the base of the petal.

6) *Add Highlights*

After painting the center petal with similar variations of reds, add the highlight by mixing Yellow Ochre and orange. The very small cast shadow is added after the center area is dry, using a deeper red/green/blue mixture.

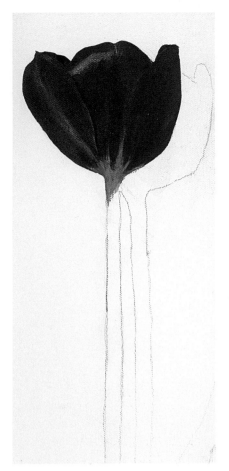

7) Separate the Petals

There is not a great deal of difference between the middle petal and the petal to the right, except where the light hits the edge and differentiates between them. The backsides of the petals are painted a dark red.

8) Mask

Mask off the stem with masking tape to make crisp edges. Sometimes pressing the tape down firmly will block any seepage of paint underneath, but to be sure I paint the edges of the stem and over the tape with matte medium and allow it to dry. Paint the stem a brownish green, not just "green," the color we assume it is. The stem is lighter on the left, more intense in the center and darker on the shadow side. The masking tape makes it much easier to vary the colors and values without worrying about the edges. Paint the leaf a greenish blue.

To mask off the curved lower portion of the stem, lay another strip of masking tape on your cutting mat and slice it, but not all the way through, at 1" (2.54cm) intervals. Place the tape on the curved part of the stem, adjusting it to conform. Repeat the masking process on the other side, seal it with medium and paint the remainder of the stem.

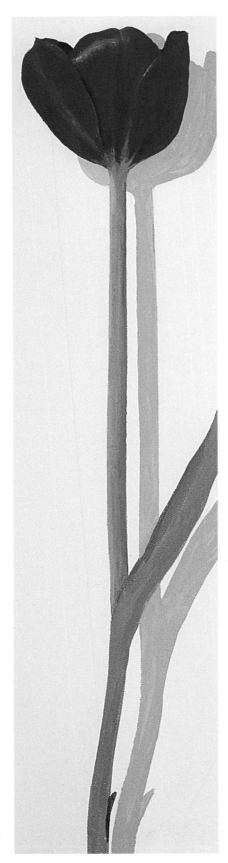

TULIP
5" x 20" (13cm x 51cm), acrylic on canvas

9) *Paint the Shadow*

For the shadow, mix a combination of Cobalt Blue and white, adding very small quantities of Cadmium Orange and black to tone it down. The shadow does not vary in intensity or value, so mix enough pigment to paint the whole shadow area.

tip

I have painted over fifteen varieties of flowers with cast shadows and they hang, unframed, over my kingsize bed. It's like having a flower garden in my bedroom. I discovered that if I mix a large batch of shadow color and store it in a covered jar, all the shadows will be the same color and intensity, giving the grouping continuity. Each portrait can be displayed individually or grouped with others and arranged in a variety of ways, such as staggering them diagonally on a stairway wall, repeating the form of the steps or hanging them in spaces between doors and windows. I had 5" x 20" (13cm x 51cm) stretchers made because my publisher, Aaron Ashley, Inc., wanted that particular size. I stretch the canvas myself, wrapping it around the sides of the stretcher bars, and staple it to the back so the staples don't show. That way the paintings don't have to be framed. Six different flower prints are available from Aaron Ashley, Inc., New York City.

PROJECT **2**) rose

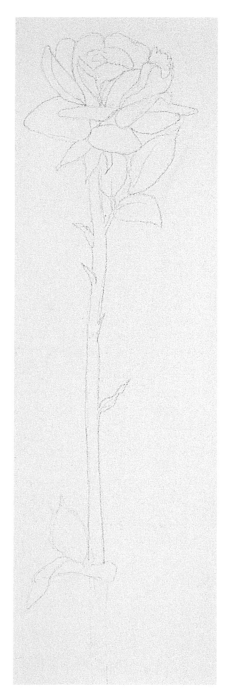

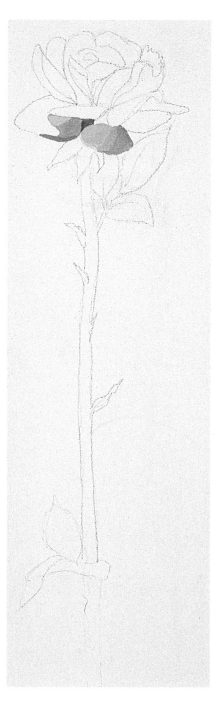

1) *Copy the Image*

Use a copy machine or trace a Peace rose from a photograph and elongate the stem to fit a 5" x 20" (13cm x 51cm) canvas. Attach the drawing to the canvas and then use black transfer paper underneath the drawing to trace the rose petals, stem and leaves onto the canvas.

2) *Paint One Petal at a Time*

The Peace rose is pale yellow with traces of pink. Alternating between a medium and small round brush, paint one petal at a time. In this small area I have used Cadmium Yellow Medium, Yellow Ochre, Cadmium Red, Alizarin Crimson, Dioxazine Purple and a mixed green. When the subject allows, work in small areas at a time because blending is easier.

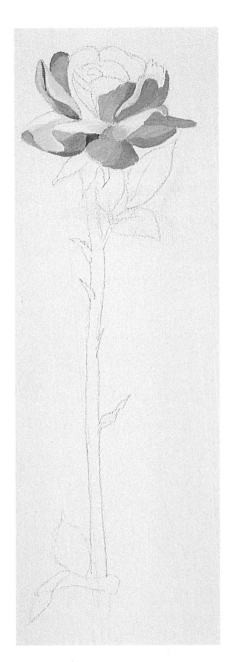

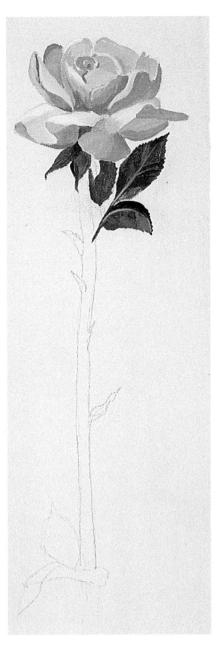

3) *Mix Colors*

Add Cadmium Yellow Light to the petals on the left, and tone down the petals on the right by adding a tiny amount of purple to your mixture of yellow, pink and orange. Tints will be adjusted, if needed, when the rose is complete.

4) *Add Leaves*

Continue painting the petals one at a time. Then paint the upper right leaf a basic green and let it dry. Paint the leaf below without letting the colors dry in between strokes and change the colors as you paint. I use Phthalo Blue, Phthalo Green, Burnt Sienna, Yellow Ochre, Raw Sienna and black for the dark greens and also use white to tint the colors. Return to the upper leaf and use similar combinations of subtle colors to give it interest. I purposely vary the painting technique of the two leaves to illustrate the different ways to achieve a result. Mix Yellow Ochre and white and use a very small round-tip brush to paint the veins on the leaves. Use masking tape on either side of the stem as in project 1 to create crisp edges and paint the stem.

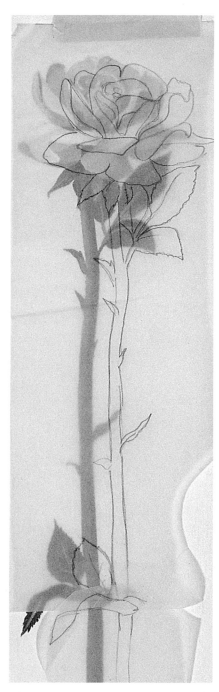

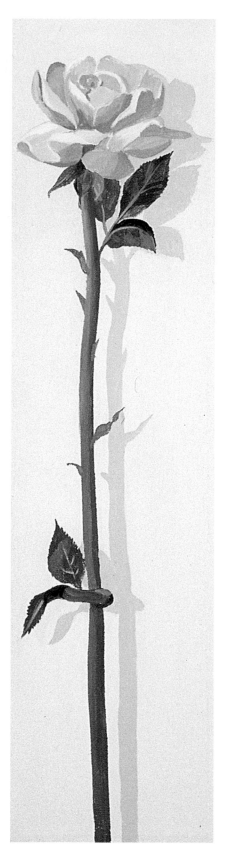

6) *Painting the Shadow*

Mix enough shadow color to paint the whole shadow area, similar to the tulip shadow in project 1, but a little lighter this time. Refer to the Tip Box on page 25.

5) *Retrace*

Take the original tracing of the rose, place it slightly down and to the right of the original painting of the rose and trace it onto the canvas to create the shadow.

PEACE ROSE
5" x 20" (13cm x 51cm), acrylic on canvas

SIMPLE FLOWER PORTRAITS

PROJECT **3** anemones

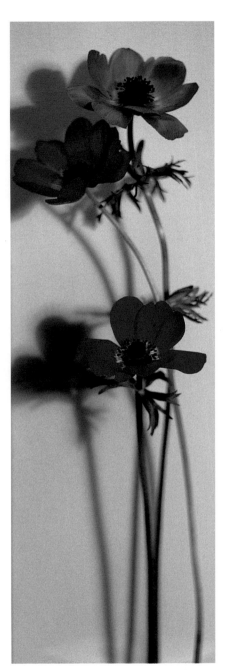 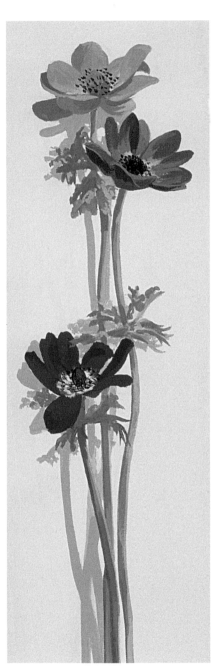

ANEMONES
5" x 20" (13cm x 51cm), acrylic on canvas, print available from Aaron Ashley, Inc.

tip
Always take a photograph of a floral still life just in case you are interrupted or the flowers start to wilt after time passes. You will have a back-up to rely on.

Painting Anemones from Life

This project is for the artist who likes to draw. Place three anemones of various colors and heights on the prongs of a frog that stands in water to keep the flowers from wilting. Put the still life in front of and near the center of a 5"x 20" (13cm x 51cm) canvas. Shine a light on the subject to create a shadow. On a duplicate canvas, draw the flowers from life. Observe the flowers constantly: their relationship to one another as well as to the edges of the canvas behind them. Draw the shadow as well. To complete the painting, use the techniques discussed in projects 1 and 2.

FUN & EASY TECHNIQUES FOR CHEERFUL SCENES

*a*rtists have endless sources of visual inspiration and thrive on interpreting and communicating their visual experience. The visual experience also triggers emotions and feelings that heighten the need for expression. This also works the other way around: Emotions can inspire the artist. While this book primarily shows you how I interpret what I see and the methods and materials I use to create successful paintings, it would do a terrible injustice if I did not also explain the emotional impetus.

I pass a farmer's garden several times a week, sometimes several times a day, and each time I go by I am amazed by how it changes. It certainly changes with the seasons, but it also changes minute by minute. A beautiful row of flowers is altered when the farmer's wife cuts a bou-

quet to sell by the roadside. Someone buys the bouquet and the scene changes again. The garden will never look exactly as it did the day I decided to stop and take photographs. What I find interesting is that I can recall all the feelings the garden triggered and the impression it had on my senses. I breathed it into my being. My memory returns and I hear the sound of the tractor in the distance and the insects close by, and I can also smell the aroma of spring flowers and newly plowed fields.

The *Farmer's Garden* demonstration shows you how to paint a landscape from far to near using simple brush techniques and color mixing, and how to create an illusion of reality in two dimensions.

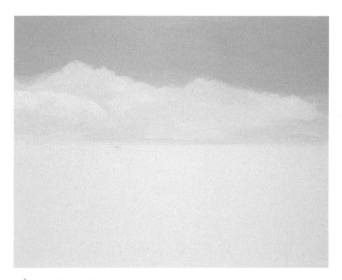

1) *Underpaint*
Paint a simple sky with low clouds down to the horizon.

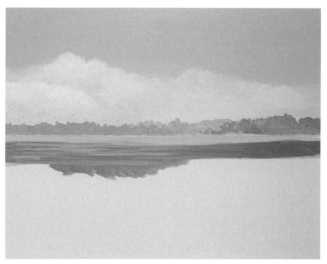

2) *Cover the Canvas*
Much of the distant landscape will be covered with midground trees and foliage; however, paint across the canvas as if nothing else is to be added.

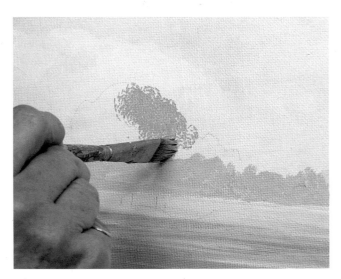

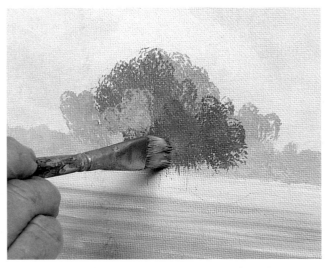

3) *Stipple*

Painting landscapes with acrylic paint allows you to work from the background to the foreground, and because it dries so quickly you can paint right over it. Use an old brush that has been splayed open permanently from use to create the foliage on the tree. A new brush can also be used by stamping it down on the palette to open up the bristles.

Photo by Mike Richter

4) *Twist and Turn*

Your hand, wrist and fingers should be constantly twisting and turning so that the stippling brushstrokes do not create a repetitious pattern. Constantly change the original greenish color by adding different pigments to the mix so that the foliage will not be static in color and value.

Photo by Mike Richter

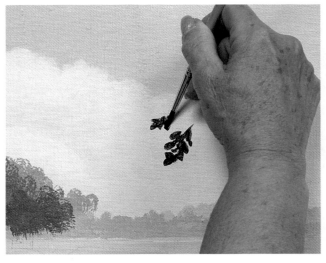

5) *Mix the Colors*

I mix the local color of the subject and, in this case, a basic greenish color to use for the leaves on the tree, and after a few brushstrokes I add another color to a portion of this mixture, changing it slightly. I repeat this process of adding other colors to the mixture, always leaving a little of the old mixture so that I can see where I have been and where I am going.

Photo by Mike Richter

6) *Hold the Brush Correctly*

Use a small round brush to paint the dark silhouettes of the leaves. Notice that the tip of the brush is pointing down because the leaves are pointing down. Use the tip of the brush for the tip of the leaf because the leaf is wider toward the branch and the brush is wider at its base. Your hand, wrist and fingers twist and turn the brush to angle the leaves in several downward directions.

Photo by Mike Richter

7) Make Adjustments

Adjust the colors used for the tree in the previous step because that mix is too bright. Lighten the green by adding a little more white to the new mixture and tone it down by adding several warm colors, such as Cadmium Red, Cadmium Orange and Burnt Sienna. Stipple the new mixtures over the first attempt, leaving a little showing through the new color. This adds depth and interest.

8) Add Leaves and Shadows

Switch to a ¼-inch (6mm) square-tip brush and paint the dense foliage in the foreground tree, adjusting your colors so the center leaves have slightly lighter, brighter hues of green. Be careful to leave little chunks of sky showing between the leaves to add depth and interest. The trunks of the distant trees are barely a shade darker than this tree but, because of the light yellowish background, they look darker. Use the same color to create shadows under the trees and on the grass. Add lighter greens over the dark green, brighten the yellow field with another coat of Yellow Ochre and white and add a brown shadow under the distant grass area to the left.

10)
Add to the Foreground

As you approach the foreground, colors become more intense. Make the dark values darker and the flower shapes larger. The large poppy pushes the garden farther back because of its relationship to the other flowers and the distant landscape.

9) Dab the Garden

Switch back to the small round brush and begin painting the flower garden by dabbing your canvas with a brush loaded with tinted yellow. Use short downward strokes. Paint small areas at a time and constantly add different colors: Each new color will have softness because it blends slightly with the damp color next to it.

The large tree pushes the distant landscape even farther away.

The subdued sky and distant landscape give the appearance or feeling of distance.

Trees and house are pushed farther into the distance in relationship to midground trees.

To see land between tree trunks adds depth.

The soft blending of diverse flowers and foliage in the garden recedes in contrast to the crisp identifiable flowers in the foreground.

The lawn area is not perfectly flat, nor is it one shade of green, and it is visible behind some of the foreground foliage.

FARMER'S GARDEN
22" x 28" (56cm x 71cm), acrylic on canvas, collection of the artist, print available from Aaron Ashley, Inc.

The predominant vertical shapes are counter-balanced by the horizontal land shapes, and the strong zigzag composition adds a little more interest and excitement to this otherwise pastoral scene.

*i*ntent leads to action and action leads to resolution and the variables between action and resolution are infinite. The choices we make between intent and resolution is called the *process*.

This demonstration of the Indian Paintbrush wildflower could be illustrated in many different styles and techniques: by one person or many, and by using any of a variety of mediums and grounds supplied by a vast assort-ment of manufacturers. The painting could be from imagination, from life or from a photograph—yours or someone else's. The point is that I made a conscious choice to paint this demonstration on illustration board using watered-down acrylic pigments in a watercolor technique.

What is your intent? Are you interested in the end result or the process itself? The process is about making choices—not excuses.

1) *Draw and Paint*
Lightly draw the petals of a wildflower called Indian Paintbrush. Paint each petal with slightly different combinations of Acra Violet, Alizarin Crimson, Cadmium Red Medium and Cadmium Red Light. The petals are lighter as they meet the stem. Add water to dilute the pigment. Also add a touch of Hooker's Green while the area is still wet to soften the edges.

2) *Change Value, Intensity, Color and Opacity*
Each blossom is slightly different from the others. The blossom to the left is darker because it is in the shade. To dull the intensity, add Burnt Sienna rather than black or gray: It makes the petals darker but they remain a warm hue.

3) *Add Values and Texture*
Use Cadmium Yellow Light and gradually add green as you proceed downward to make different values of yellow/greens. Tiny brushstrokes create the illusion of texture. Adding Cadmium Yellow Medium on top of and next to the Cadmium Yellow Light adds warmth.

4) *Add Another Flower*

Continue to block in the bushy yellow plant, and add a bright red/orange Indian Paintbrush behind it.

5) *Define the Shapes*

Although you refer to your photographs of wildflowers, you are free to arrange and place them where you wish. Add blue/gray to the left; make that mixture darker and paint over the first layer in some areas. While that is still wet, dab in a little yellow/green, creating greenish gray water blossoms. To make a warm dark green, add Burnt Sienna to the green on your palette and stroke in more stems and leaves using a small round brush.

6) *Add Finishing Touches*

Tone down the yellow bush and add a transparent warm greenish brown over some of the blossoms and paint opaque brownish stems and leaves. To balance warms and cools, add a warm mixture of Burnt Sienna and Raw Sienna towards the top and over some of the blue.

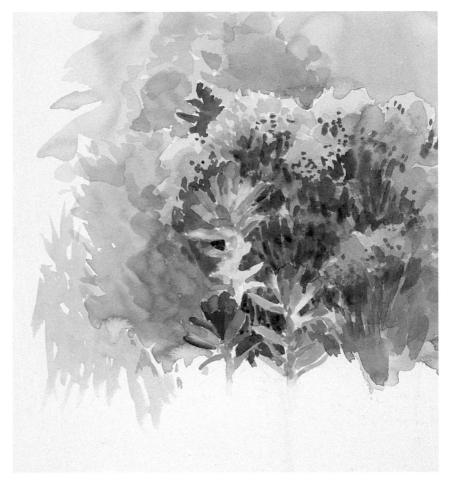

INDIAN PAINTBRUSH
8" x 10" (20cm x 25cm), acrylic on illustration board

PROJECT 6) portrait of a lily on a pre-painted background

*P*art of the creative process is trying new techniques, thinking of different ways to portray a subject and then figuring out how to go about achieving it. In my opinion, thinking about what and how to paint is about 90 percent of the actual painting process—sometimes even more. It's important to think of how a subject can be enhanced. In the demonstration *Portrait of a Lily*, I decided that an interesting background would enhance—rather than subordinate—the simple lily.

I constantly use my file of resource photo prints and slides for inspiration as well as creation. To demonstrate an easy way to paint a portrait of a lily, I use a slide of a yellow lily taken at its peak of bloom. Then I project it onto a pre-painted canvas that has subtle pastel designs created with a minimum of effort, and allow it to dry. The lily is traced over the background and painted opaquely. The contrast between the transparent, ethereal background and the solid rendering of the lily adds excitement and interest to this simple subject.

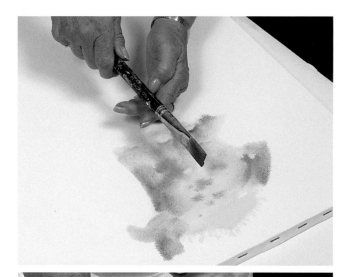

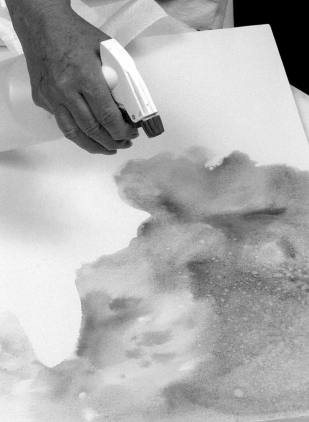

1) *Mix the Paint*

To observe how paint moves only in the wet area, place a stretched canvas on top of a table and wet an area with clean water. Leave an irregular shape dry near the center.

Mix color with water to dilute its intensity and lightly brush or drop it in a small part of the wet area. Change colors constantly using analogous colors that will blend well together. Also spatter color by tapping your loaded brush against your hand to make small blossoms of color.

Photo by Mike Richter

2) *Spritz*

Continue adding diluted colors, and occasionally give a little spritz of clear water into a painted area that is just beginning to soak into the canvas. Too much water will make the paint runny, but just a little will create little whitish blossoms. This is similar to a technique used for watercolor painting.

Photo by Mike Richter

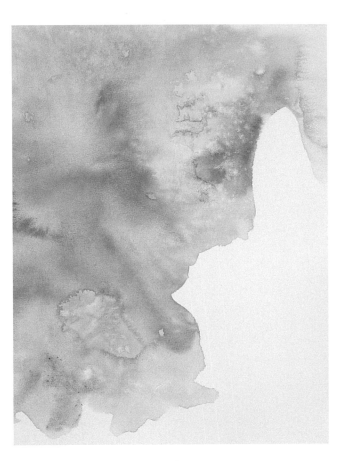

3) *Let It Dry*

Crisp edges form where the paint stopped near the dry areas. The colors blend by themselves when not overbrushed, and if you look closely you can see the mottled effect of the water spritzes.

4) *Project the Image*

I chose a beautiful lily from my slide file and projected it onto my canvas. The background is completely dry, and light enough to see the pencil lines when you trace the image onto the canvas. When the tracing is finished, I project the lily on my rearview projection screen and refer to the image as I paint. The image can also be projected onto a white wall, a canvas or a board that is at a right angle to the lens.

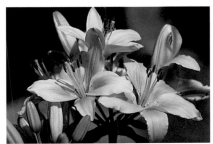

PORTRAIT OF A LILY 22" x 28" (56cm x 71cm), acrylic on canvas

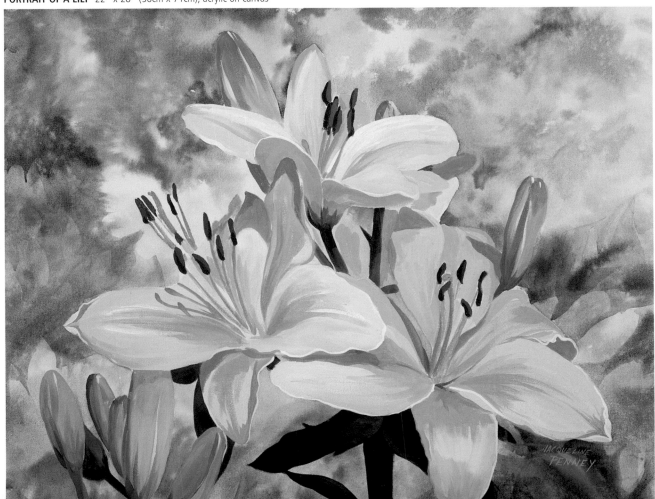

PROJECT 7 beautiful weeds &
queen anne's lace
on canvas

*t*his book graphically explains my method of painting and
what tools and techniques I use. The ideas, interpretations
and demonstrations are not unique—but they are unique-
ly mine. I encourage you to copy any of the exercises in this
book. Begin anywhere and follow my directions. Allow
yourself time without judgmental criticism, and express
yourself in your own unique way. It isn't something that
hasn't been done before—it's something *you* haven't done
before. Take the risk.

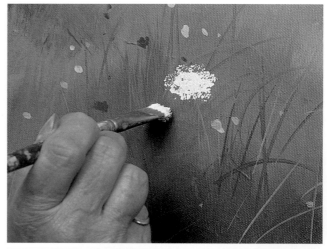

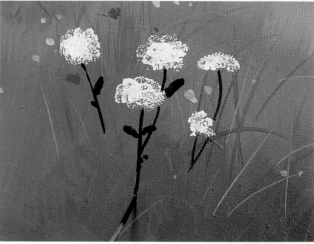

1) *Stipple*

On a background of previously painted grasslike foliage, stipple
white paint to create a Queen Anne's lace blossom, using an old
¼-inch (6mm) square-tip brush that has been splayed with use.
Photo by Mike Richter

2) *Use Downward Brushstrokes*

Create the stem by starting at the base of the flower and using
a small rigger or liner brush, making a downward stroke. Then
add leaves with a small round brush.
Photo by Mike Richter

3) *Use Upward Brushstrokes*

Using a no. 3 rigger brush, create blades of grass using a
sweeping motion, starting at the bottom and releasing the
pressure as you go up to bring the grass tips to a fine point.
After every few strokes change the color slightly and continue.
Photo by Mike Richter

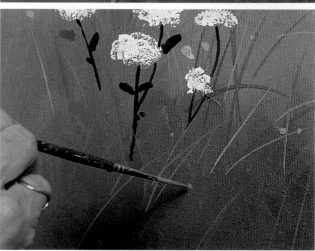

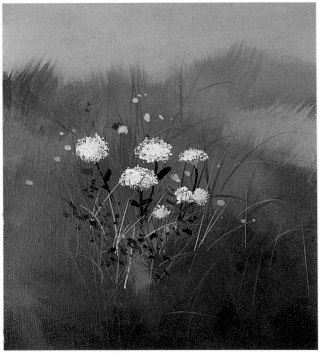

4) *Use Broad Strokes*

To create clumps of grass, use the broad side of a ½-inch (12mm) square-tip brush that is slightly splayed open. Make one or two sweeping strokes from the bottom up, releasing the pressure as you finish each stroke. The paint is deposited when the brush is pushed into the canvas at the beginning of the stroke and as the pressure is released on the upward stroke, just the very tip of the bristles touch the canvas, creating tiny lines that resemble thin grass tips. This is accomplished with two or three swipes of the flat brush, beginning almost directly over the first stroke but fanning out at the top.

5) *Use a Rigger Brush*

Load a rigger brush with the same color and use the same type of stroke to make the grass even longer emerges from the short clump. The more varied and numerous the strokes are, the fuller and more interesting the clump of grass becomes.

"

Change and risk-taking are normal aspects of the creative process. They are the lubricants that keep the wheels in motion. A creative act is not necessarily something that has never been done; it is something you haven't done before.

MARGARET MEAD

"

6) *Use a Liner Brush*

Using a liner brush, add leaves, more blossoms and lighter and darker grasses and continue alternating and overlapping these objects to create depth and interest.

The strong angular shapes of the sail-boats that overlap the docks and the distant island balance the dominant horizontal format and its subject.

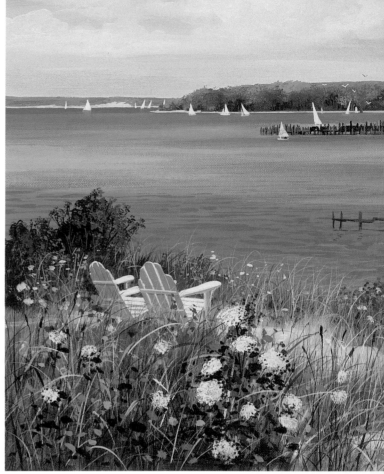

The Queen Anne's lace is combined with other colorful weeds and grasses in the foreground to add interest.

The very large area of Queen Anne's lace in the foreground is a darker value than in **The Race.** Their size is enough to bring the viewer's attention to them without needing to paint them a glaring white.

The puffy white clouds repeat the shape and color of the Queen Anne's lace.

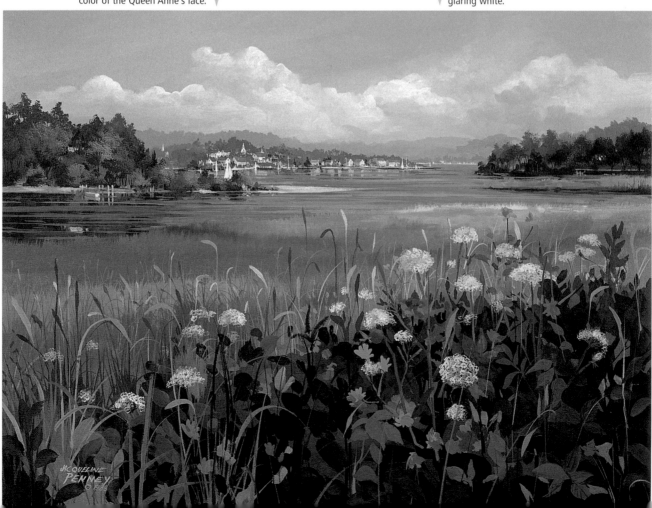

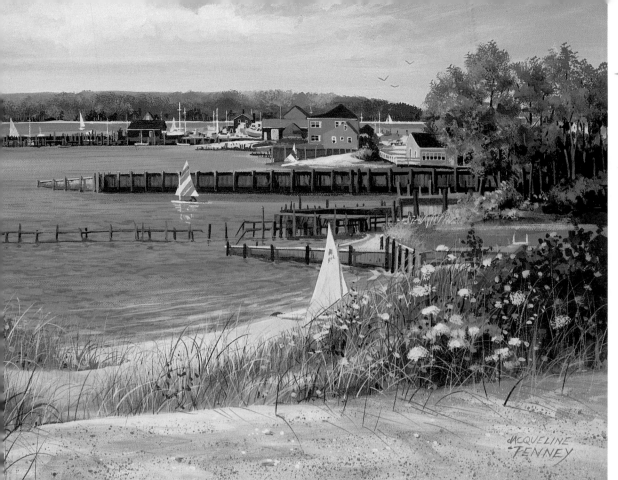

The roundness of the midground trees repeats the round clumps of Queen Anne's Lace.

The size of the blossoms in relation to the two chairs, the sailboats, the island and the distant shore creates an expansive feeling of depth.

THE RACE
15" x 30" (38cm x 76cm), acrylic on canvas, collection of Barbara Stype, print available from Aaron Ashley, Inc.

The small details and the activity in the distance keep the viewer busy and balance the large area in the foreground. The pale blue flowers are similar to the color of the water and bring a welcome relief to the warm patch of weeds and flowers, and also connect the foreground to the background sky and water.

The secondary warm colors are repeated in the distance with less intensity and also connect the two areas of the painting.

HARBOR TOWN
22"x 28" (56cm x 71cm), acrylic on canvas, collection of the artist, print available from Aaron Ashley, Inc.

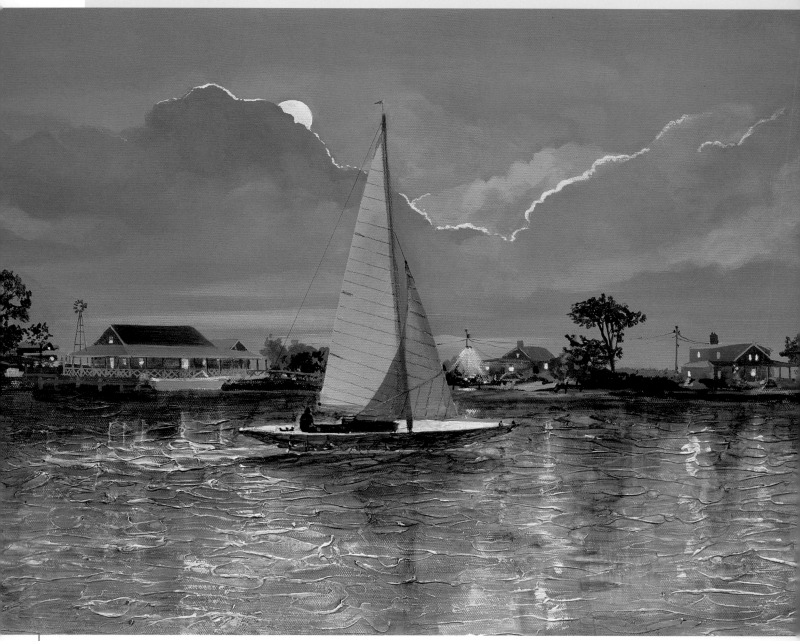

RACING WITH THE MOON
15" x 30" (38cm x 76 cm), acrylic on canvas, collection of Mr. & Mrs. James Hooghuis, published by Aaron Ashley, Inc.

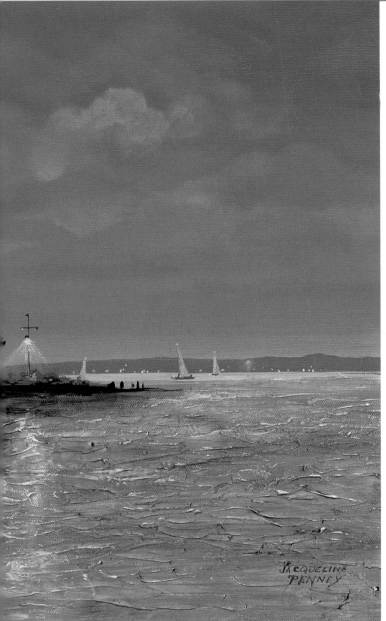

sky, water and land

Think of the horizon line as a division between earth and sky. The earth may be round, but when you paint distant land or seascapes the horizon appears flat. Even when you are painting a distant mountain range, it rests on a flattish landscape. On a clear day the sky may be quite blue above the mountain range: You cannot see the lower portion of the sky hidden behind the mountains. If, however, you are painting a flat landscape or seascape, even on a clear day, the upper portion of the sky may be a little brighter than the lower portion. When you look out into the distance, your vision is affected by the atmosphere. The distant mountain range itself will appear less intense near its base for the same reason.

The weather and a feeling you wish to portray must also be considered. Each hour, day, week, month and season is different, and the artist gathers inspiration from the everchanging conditions. Sun produces long shadows in the morning and afternoon, and at midday covers the scene with brightness. Consider the colors of dawn, twilight and moonlight. One scene can be changed in hundreds of ways by altering the subject slightly, but it can also be changed by the weather conditions, such as how it would look in haze, fog, rain or snow, or when it is bright, dull, cloudy, clear, calm, stormy, hot or cold.

A student once asked if she should just add more water to the sky color when she wanted to paint fog. Fog is wet but what we see and what we know are two different things. Painting is an illusion of reality and requires "seeing," not "knowing." Yes, fog is very wet atmosphere, but if you look carefully, using a painter's eye, you will notice the close relationship of values to anything that emerges through the fog. It is a matter of seeing, not thinking.

BILLOWING CLOUDS

THE RIGHT BRUSH

Choose a brush to fit your need. When you work in a large area that doesn't require great detail, such as billowing clouds or a large expanse of water, use a large brush because it covers more space in less time. Adding only a small amount of water to the paint helps the paint flow onto the canvas; the paint remains pliable longer, making blending of subtle colors and values possible. Too much water dilutes the pigment, making it transparent rather than opaque, and actually makes the paint dry faster.

There may be days when the sky is just as blue as blue can be or, depending on where your viewpoint is, it may not even have much value or color change. I cannot imagine painting the sky with tinted blue (blue and white

mixed together) alone. When you look at possible land or seascapes, you look outward, into the distance, not upward. We do not look up to see what color the sky is, but out in front of us. The atmosphere, reflected light and distance affect the color of the sky—and it's rarely just blue.

When painting a more detailed sky and the paint begins to dry, making blending more difficult, it is a good time to allow the area to dry thoroughly. Take a rest, sit back and make mental notes about what needs to be done. Mixing the exact color again is almost impossible and, as far as I'm concerned, a waste of time. Drybrush technique can be used on top of a dry area to blend colors and values; it is explained in step 7.

1) *Load the Brush and Mix Color*

Prepare a 1½-inch (38mm) bristle brush by first wetting it and then squeezing out the excess water with a paper towel. Always have a paper towel handy for this purpose. Load the brush with white pigment and place the pigment in the middle of your mixing area.

While the brush still has white pigment on its bristles, swipe some Cobalt Blue from the edge of the dollop and mix it thoroughly with the white. If the paint feels too thick, dip the tip of the brush in water and continue mixing.

Photo by Mike Richter

2) *Note What Tint Looks Like*

Just a blue and white tint does not make a natural-looking sky. The opposite of blue on the color wheel is orange, its complement. Add a very tiny amount of orange to your brush to tone the blue down. It's a very slight change in hue, but an important one. If you want the sky a little darker, add a very small amount of black or Payne's Gray. Mix the paint thoroughly, working the pigment into the bristles.

Photo by Mike Richter

3) *Paint the Sky*

Paint the blue of the sky first, creating cloud shapes by leaving the white of the canvas where the clouds will be. As you require more of the sky color, do not add water to extend the mixture, but do continually add more of the original combinations, even changing from Cobalt Blue to small amounts of Ultramarine, Phthalo Blue and Cerulean Blue, always adding white. Blend these new additions of color right on the canvas, working them into the paint that is still wet and pliable. The subtle changes of blue make the sky more interesting.

Photo by Mike Richter

4) *Make the Clouds*

Quickly clean your brush and load it with white. Put pigment in the mixing area, add a small amount of Yellow Ochre to make a warm white for the clouds and mix it thoroughly with your brush. Paint the upper cloud shapes first, blending some of the edges into the blue that is still wet to create soft edges.

Photo by Mike Richter

5) *Scumble With a Dry Brush*

After the sky color dries, use a drybrush technique to extend the clouds on the left by extending the white into the sky. To do this squeeze out any excess moisture from your brush with a paper towel and work white pigment into the tip of the brush without adding water. Then, holding your brush flat to the surface of the canvas, gently apply the paint in a circular motion. This technique is also useful for wispy clouds. Continue painting the clouds downward and, as you near the horizon, add a little more warm color to the mixture already on your palette. Make it a little darker by using a very small amount of Burnt Sienna and the blue mixture.

Photo by Mike Richter

7) Create Straight Lines

Mix a gray/blue/green color for the water and place the bottom edge of a ruler on the horizon line. Holding your brush at right angles to the canvas, brush across—using the edge of the ruler as a guide—to create a very straight line. Remove the ruler and continue to paint the water down to just below where the land begins. Don't be concerned about going too far down because the grass, lighthouse and land will be painted right over it.

Photo by Mike Richter

6) Measure the Horizon

Water seeks its own level and the horizon line must also be level. Measure down equally on both sides of the canvas and mark it. Then draw a light line connecting the marks to create a perfectly level, straight horizon.

Photo by Mike Richter

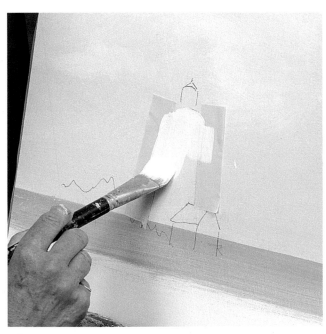

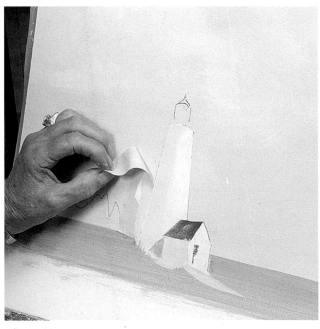

8) *Mask*

Draw the lighthouse. To create nice crisp edges, place two strips of masking tape on either side of the lighthouse and paint matte medium over the edges to be painted. This prevents paint from bleeding under the tape and allows you to adjust the light and shadow sides of the lighthouse without being concerned about the edges. Add a little Yellow Ochre for the sunny side and make the shadow side a mixture of blue just a little darker than the sky behind it. Put two coats of paint on the lighthouse to completely cover any of the background that might show through.

Photo by Mike Richter

9) *Remove the Masking Tape*

When the lighthouse area dries, remove the masking tape.

Photo by Mike Richter

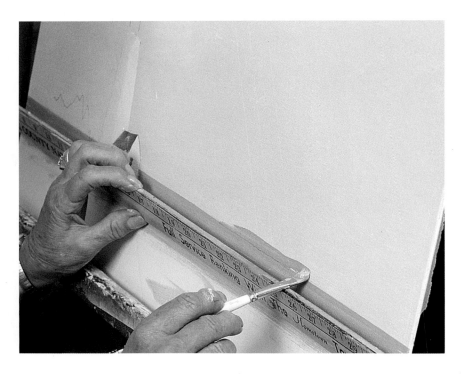

10) *Steady Your Hand*

Use a yardstick to steady your hand and guide a small square-tip brush across the canvas to paint the distant land. Vary the pale grays/greens.

Photo by Mike Richter

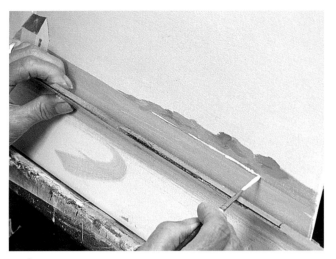

11) *Make a Strip of Land*

Mix Yellow Ochre and white for the beach color. Rest a small rigger brush on the yardstick and paint the land in.

Photo by Mike Richter

12) *Create Ripples*

Use pure white on your rigger brush, continuing to rest it on the yardstick, to create small waves. Add a tiny triangle for a boat in the distance.

Photo by Mike Richter

13) *Add Small Details*

To paint the tiny sailboat in the distance, steady your hand by resting your pinkie finger on the canvas.

Photo by Mike Richter

LIGHTHOUSE CHANNEL
22" x 28" (56cm x 71cm), acrylic on canvas, collection of Mrs. Nancy Hill
Crisafulli, print available from Aaron Ashley, Inc.

The low horizon emphasizes the soft billowing clouds.

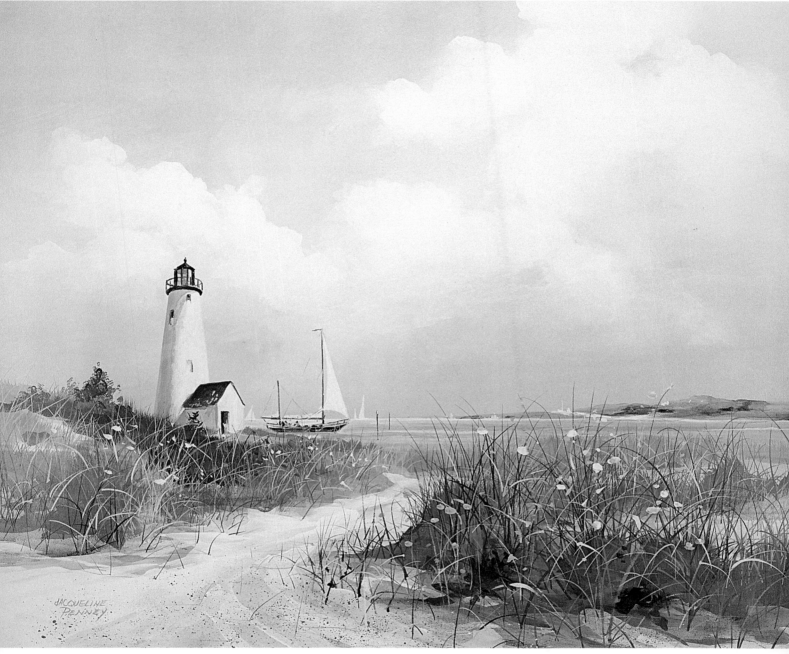

The white sandy road leads the eye toward the lighthouse and the sailboat, and also repeats the soft whiteness in the foreground.

The red of the roof is repeated in the grass area to give added warmth to a predominantly cool painting.

The boat is not under full sail, adding to the feeling of a lazy summer day.

The blue shadows in the grass area repeat the color of the sky and water.

Many subtle mixtures of green in the foreground and distant landmass anchor the subject down, emphasizing the billowing clouds even more.

MOONLIT CLOUDS

INSPIRATION

remember Vaughn Monroe singing his theme song, *Racing With the Moon*, when I was a young woman. It was one of my favorites. When my publisher asked me to paint a moonlit water scene, that song came to mind and became my inspiration. I composed a scene using a reference photograph of a nearby area and a separate photograph of a sailboat. Both photos were taken in the daytime.

With a little imagination it's easy to take a daylight scene and convert it into a night scene, because everything is just darker. The moon lights up the sky, backlighting everything in front of it and creating silhouettes, shadows and reflections.

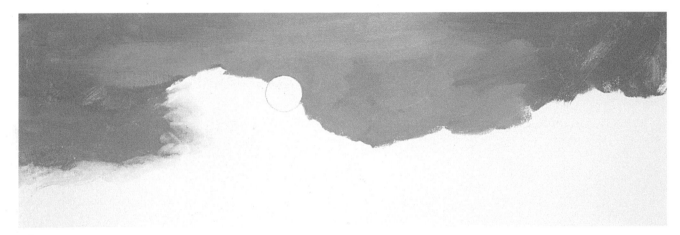

1) *Draw a Perfect Circle*

Use a compass to make a perfect circle for the moon. Because you want the sky to be a dark midtone, load your 1-inch (25mm) square-tip brush with Cobalt Blue and a touch of white. Then add a tiny bit of Cadmium Orange and black to tone it down and darken it more. Begin in the upper lefthand corner and paint around the moon. Continually add small amounts of other pigments to the mixture to make different combinations of blue. Lighten areas by adding white and orange to the mixture, giving warmth to the clouds that are in the distance.

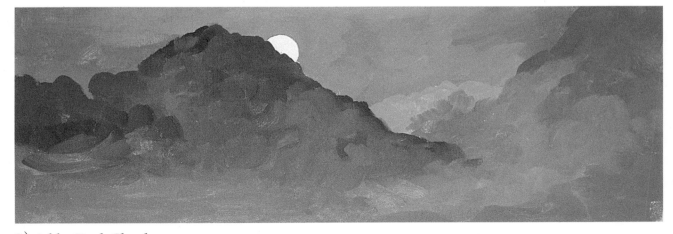

2) *Add a Dark Cloud*

Because the cloud in front of the moon is darker, add more of the blue/black/orange combination to the mix and use less white paint. Continually alter your colors, values and brush-strokes to give the clouds motion and depth. As you near the horizon, lighten the sky a little.

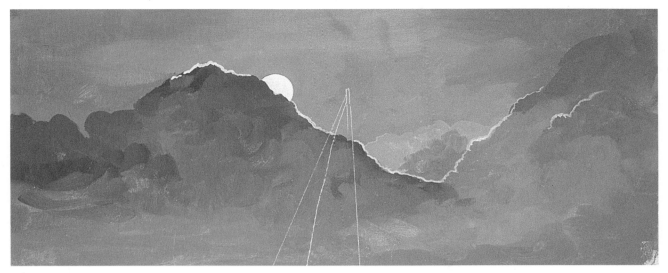

3) *Use Transfer Paper*

Transfer paper is available in several colors as well as white. Trace the sail and rigging, using the white transfer paper, directly onto your canvas. The luminosity of the sails against the dark background is better achieved by painting the sail white. Because the background is so dark, it may take two or three coats of white pigment, allowing it to dry in between applications, to cover the dark background. You could have used this technique fcr the moon as well, rather than interrupting the sky brushstrokes to paint around it—but there are usually several ways to achieve the desired effect and this is just another way to do it.

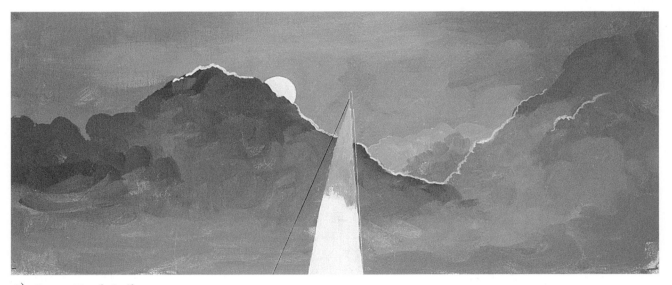

4) *Create Dark Sails*

For the color of the moonlit sail, mix Raw Sienna and white and carefully paint inside the white guidelines. To give the moon a warm glow, glaze over it with just a tiny touch of Yellow Ochre. Use a small-pointed permanent black marker pen and a ruler to make crisp rigging lines.

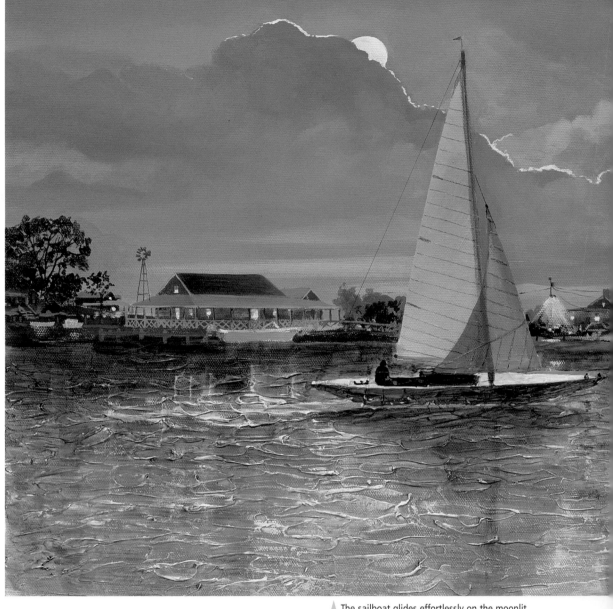

The sail points like an arrow to the moon that peeks from behind the clouds making everything else subordinate.

The lighted windows act as a beacon for the boat's return journey and create reflections on the calm water.

The sailboat glides effortlessly on the moonlit water to join other boats enjoying the brightness of the early evening sky.

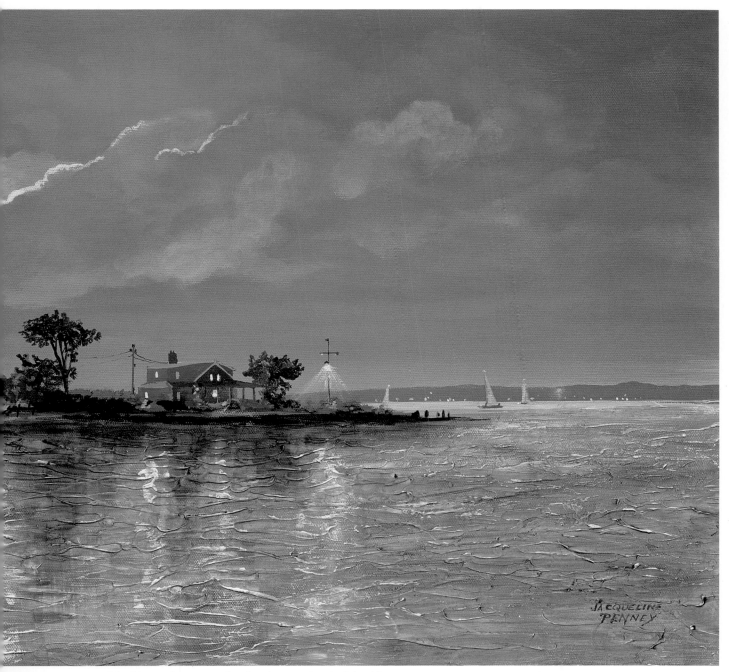

A nostalgic old song that I remember from long ago inspired the title of this painting.

RACING WITH THE MOON
15" x 30" (38cm x 76 cm), acrylic on canvas, collection of Mr. and Mrs. James Hooghuis, published by Aaron Ashley, Inc.

TWILIGHT SKIES

CREATING A MOOD

Sunset is a magical time. The glow of twilight has inspired musicians, poets and artists for centuries and I, for one, love to watch the afterglow it creates. Rather than look directly at the sunset, I like to look away from it and see what that bright, warm spotlight shines upon. Everything takes on a warm glow, and the sun nearing the horizon creates long, deep shadows.

After Glow was inspired partly by my garden and partly from wishful thinking. My small but beautiful garden does not overlook the water—I just pretended that it did. There is an impressionistic quality I wanted to capture, so I used smaller brushes to dab on the colors, giving it the romantic feeling of a Manet, Monet or Renoir style.

A trip to Boca Grande on the West Coast of Florida inspired *Beached*. I referred to several photographs in my file to create this late–afternoon painting, when the sky becomes warm and the shadows deepen and yet tell a story that it is still too early to end the day on the water.

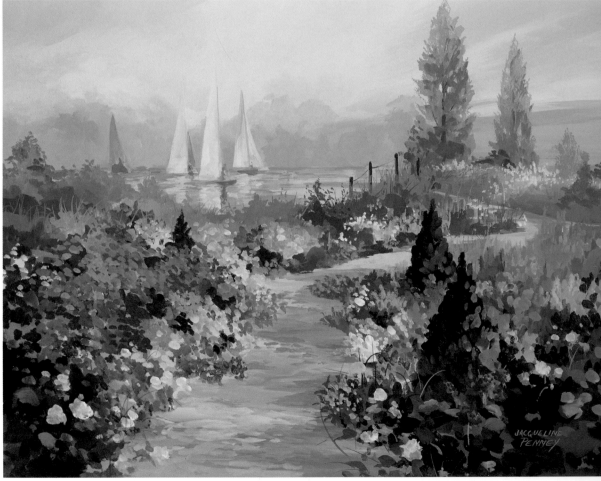

White sails create a yellowish reflection on the fairly calm water.

Tall trees break up the sky plane and repeat the shape of the sails.

Note the soft transition from sky color to cloud color without sharp edges.

Clouds become darker near the horizon, contrasting with the sunlit sails.

The horizon line is not sharp and gently blends into the sky.

As the flowers and foliage recede up the path, they become less pronounced and more subtle.

Foreground colors are brilliant and intense.

AFTER GLOW
22" x 28" (56cm x 71cm), acrylic on canvas, collection of the artist, print available from Aaron Ashley, Inc.

The path leads the eye into the painting and up the slight incline to the handrail, which leads the viewer down to the water and distant boats.

The sky reflects the warmth of the late-afternoon sun.

Long shadows tell us the sun is low and point like arrows toward the sea.

The palm trees repeat the angle of the sails and give a feeling of being windblown.

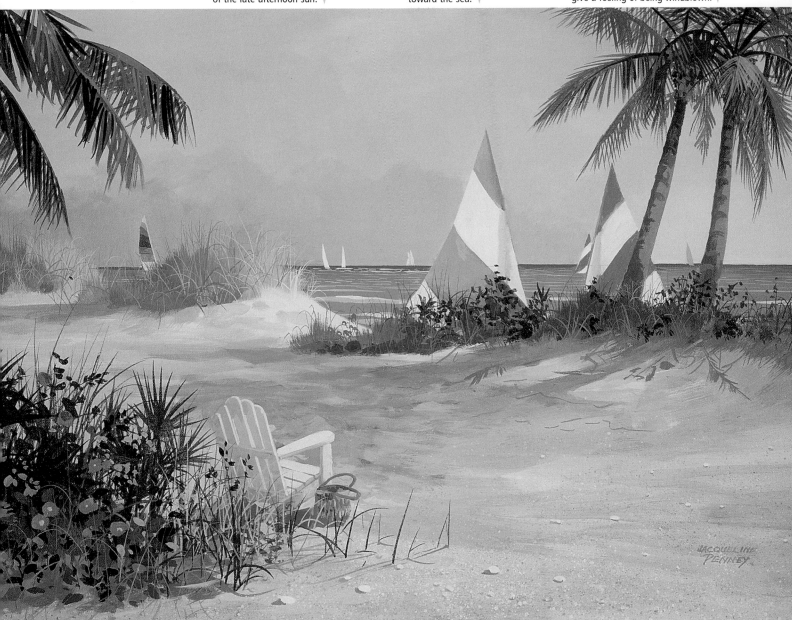

The chair faces toward the water activity with a good possibility of being occupied in the near future.

The colors of the fore-ground flowers and the colorful bach bag are repeated in the sails.

BEACHED
18" x 24" (46cm x 61cm), acrylic on canvas, collection of the artist, print available from Aaron Ashley, Inc.

STILL, REFLECTIVE WATER

IMAGINARY SEASCAPE

a lot can be learned from observation and reference. For instance, if you look out at a large body of water and hold a level to the horizon line you will see that it is perfectly level. Flowing water is not level but still water is, no matter where it is, with the exception of outer space. You can use a pencil, ruler or piece of paper, all having straight edges, to use as a reference tool that will help you to see gradual curves, angles and relationships.

This demonstration is totally conceived in my imagination. I have painted so many seascapes and landscapes that I have experience and skill to guide me. Use photographs or go on location to paint and develop *your* skill and ability. It is said that experience is the best teacher, but a good teacher makes the experience more interesting. In lieu of a good teacher, read books about perspective, drawing and technique, study the old masters, go to museums and galleries and feast your eyes on the extraordinary scope of the art world. Become inspired!

1) *Begin With the Sky*

Compose the landscape lightly in pencil and paint the sky with a mixture of Cobalt Blue, Cadmium Orange, Payne's Gray and white. Toward the horizon, add a little Phthalo Blue. Apply a very light tint of white and Yellow Ochre for the clouds. Because the background is still quite wet, you will have to repeat this process again later when it is dry. Beneath and to the left of the clouds, use a very light mixture of Payne's Gray and white for the shadows.

Using the sky color mixture that is still wet on the palette, add lavender, Raw Sienna and green to make a warm hue that is a light-medium value for the distant land.

Continuing with the same mixture, add more pigment to make it a little darker and greener for the land to the right that is closer to the viewer. Note that the shoreline is ¼" (0.64 cm) below the actual horizon, giving it the illusion of coming forward. Wait for the sky to dry before you stipple in the foliage.

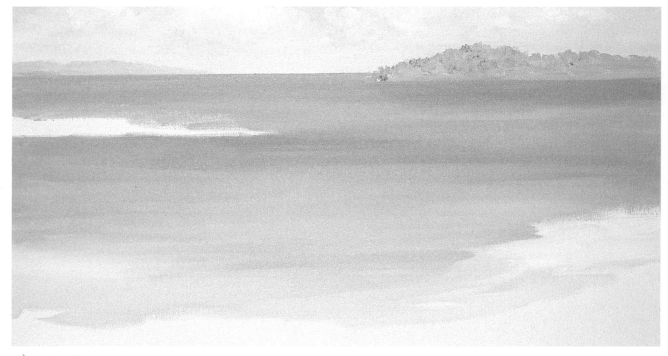

2) *Paint the Water*

Since water basically reflects the sky, make the body of water a little darker and grayer than the sky color. Vary the basic blue/gray color of the water with additions of Ultramarine Blue and Phthalo Blue as you descend toward the foreground. With each new addition, go back and brush in long horizontal strokes to the area just above. The slightly different hue and value give the illusion of swells in the otherwise calm water. As you approach the shallow water, add white, Yellow Ochre and Raw Sienna to the mixture to give the illusion of sand underneath the shallow water.

3) *Rework Distant Land*

When the distant land is dry, use approximately fifteen or twenty different varieties of green to stipple in the trees using an old square-tip brush that is splayed open with use. Use a small round brush to apply darker colors and a variety of foliage.

With vertical strokes and a dry brush, apply a greenish color for the reflections of the trees on the water. The reflections are basically the same shape as the trees in reverse. Using a mixture of white, Yellow Ochre and Raw Sienna, begin the spit of land on the left and add a little beach area.

4) *Add Details*

To give more interest, I add a house and dock on the distant land. The distant land is too far away for precise details, but colors are applied to the land for the beach; the trees and grassy areas are repeated on the water. Using a ruler to steady your hand, paint thin light blue stripes with a rigger brush in long broken lines to make distant ripples. This immediately pushes the reflections into the water, and the ripples now become dominant in that area.

Switch to a small square-tip brush and, using the ruler to steady your hand, make slightly thicker ripples. Vary the pressure on your brush, making the strokes of color thin to thick to thin again. As the brush loses paint, apply more pressure and drybrush in some of the ripples.

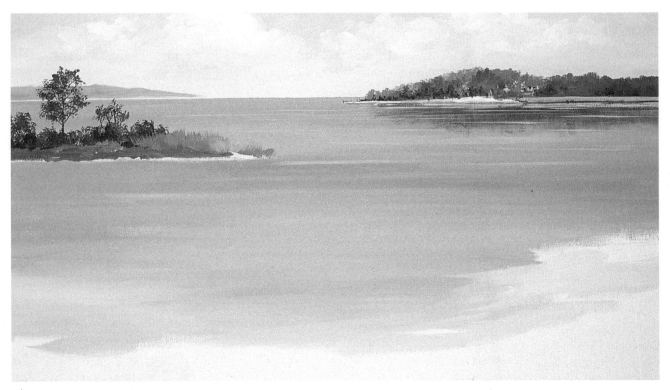

5) *Add More Details*

Now that the distant water is complete, concentrate on the small spit of land to the left and stipple in trees and foliage, using a small rigger brush to paint the trunks and branches.

6) *Paint Grasses*

Use a square-tip brush to create the grasses near the water. For each stroke of a greenish color that is pulled upward, also stroke the same color downward. This creates the exact mirror reflection on the water. The more varieties of green you use, the more interesting the grass area becomes.

7) *Repeat Grass Strokes in the Water*

The mudflats, sand and single blades of grass are all repeated in the water.

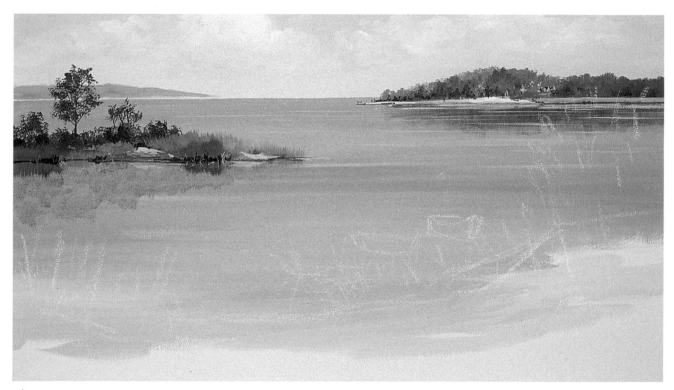

8) *Create Reflections With a Glaze*

There are a variety of ways to paint reflections. One method is to use a greenish color and glaze over the water. When the glaze is dry, use white chalk to reestablish your drawing.

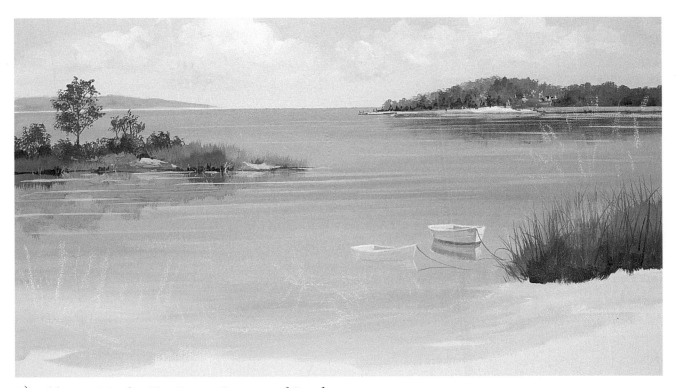

9) *Add More Ripples, Two Boats, Grasses and Beach*

Add more ripples and paint the two rowboats and their reflections. The general rule is that white will reflect a little darker and dark will reflect a little lighter.

To paint tall grasses, begin with a square-tip brush that is slightly splayed and make several upward strokes with your color. Immediately switch to a small rigger brush, dip it into the same color mixture and extend the grass. This takes many brushstrokes but accomplishes the illusion of dense grass. This one area uses four different shades and tints of green.

The sand goes between the shoreline grasses and the taller reeds because it adds to the feeling of depth when objects overlap. Paint the sand with a mixture of Yellow Ochre and white.

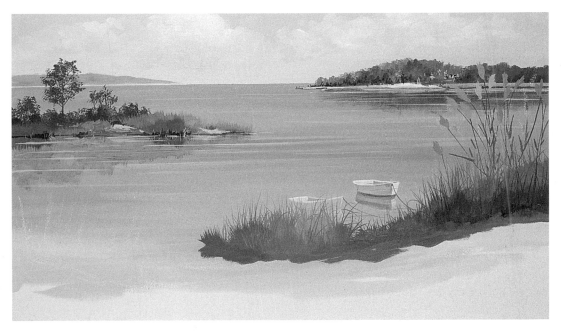

10) *Begin the Foreground*

Continue painting the grass with many varieties of greens, and also paint the tops of some of the tall reeds, bringing them up and over the horizon, again creating a feeling of distance by overlapping.

11) *Add More Definition*

Paint the bottom portion of the reeds over the beach and add more grass to the left foreground, repeating the colors used previously and the brushstrokes explained in step 6.

12) *Add a Warm Glaze*

To create a warm glow coming from behind the reeds, glaze over that area with Yellow Ochre, Raw Sienna and Burnt Sienna. A dark brownish glaze makes the sand look wet and muddy near the water. Spatter the beach area and add shadows.

13) *Make Changes*

After looking at this painting for several days, you can make a major change in the foreground. Add a variety of color glazes to the wet beach area to make it larger, and paint taller beach grasses behind the dry sand area to give the painting more depth. The pathlike area to the right gives the illusion of more elevation and pushes the wet sand area farther back. Also note the small sailboat in the distance.

The small jetty of land in the foreground is approximately the same size as the land mass on the right. The tree that overlaps the water and distant land, in relationship to the tiny sailboat, creates more depth.

The distant horizon line is perfectly level.

The land on the right is almost level and about ¼'' (0.64cm) down from the horizon line, bringing it closer to the observer. The trees are reflected in the water and the sailboat overlaps the land, pushing it farther into the distance.

The gentle curve of the reeds that overlap the water and distant land indicates a very slight breeze, not enough to roughen the surface of the water, but just enough to power the sailboats.

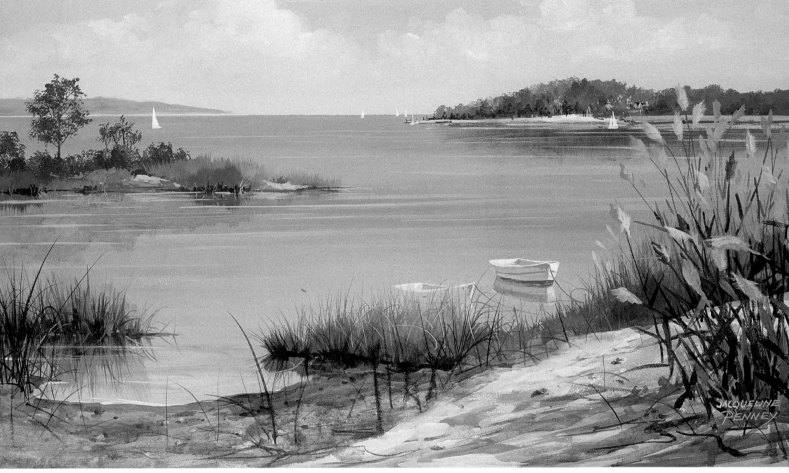

The transition from blue water to yellowish water is gradual and appears to be transparent, yet still reflects the sea grasses on its surface.

Soft horizontal ripples on the water accent the serenity of the scene.

The wet sand is dark and the dry sand is light, adding interest.

The rowboats add interest to the scene, and the crisp reflection adds to the tranquility.

Long cast shadows on the beach indicate the light source and pull the eye to the left and into the painting.

Nothing is painted with just one hue. Each area in the painting is made with a multitude of similar colors.

REFLECTIONS
16" x 28" (41cm x 71cm), acrylic on canvas

FOG

CLOSER VALUES

a student once asked if she should just add more water to the sky color if she wanted to paint fog. Fog is wet, but what we see and what we know are two different things. Painting is an illusion of reality and requires "seeing," not "knowing." Yes, fog is very wet atmosphere, but if you look carefully, using a painter's eye, you will notice the close relationship of values to anything that emerges through the fog, so it is a matter of seeing—not thinking. Although fog is wet, you do not add a lot of water to your paint to create fog: The illusion of fog is created by the close relationship of values. If you look at a black-and-white photograph of a fog scene this becomes more evident. The distant values in daylight are pale gray, sometimes almost white; the midground becomes a little more distinct, with more variations of gray; and the foreground can be quite clear.

I did not use a limited palette for the painting *Maine Fog*, but I would suggest trying a limited palette of Ultramarine Blue, Burnt Sienna, Yellow Ochre and white as an exercise. These three colors challenge the artist to mix variations of color and value with less confusion; it simplifies painting a fog scene and is a good exercise for artists at any level of expertise.

1) *Utilize Close Values*

The sky and distant land are very close in value. Paint a medium blue-gray sky. Then add a little Phthalo Blue, Phthalo Green and black to that mixture to make a slightly darker value and paint the trees, land and water.

2) *Establish Values*

Paint the light area first, which is the huge slab of rock in the foreground, and then use a darker value for the midground. Use combinations of Yellow Ochre, Raw Sienna, Burnt Sienna, Cobalt Blue, black and white.

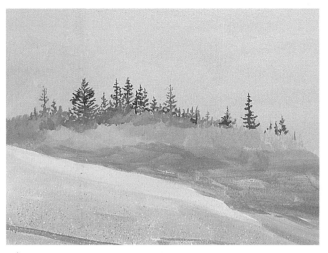

3) *Spatter*

Before painting any details, spatter the rock area with a variety of colors using a toothbrush.

4) *Define Trees*

Use a combination of Phthalo Green, Burnt Sienna and black, mixed with a little white, to define the tops of the trees, lightening the mixture as you near the land. Drybrush a bluish white mixture over the land and the water.

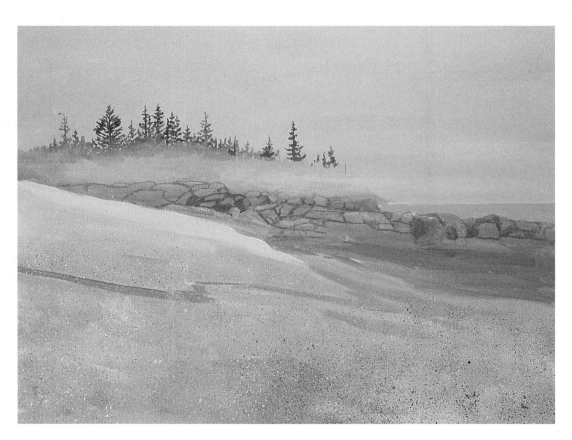

5) *Draw With Your Brush*

Use a transparent wash of brown to delineate the rock formation, actually drawing with your brush.

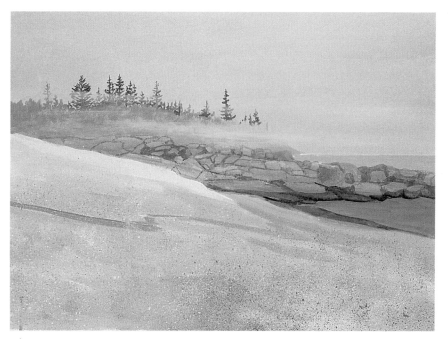

6) *Define the Rocks*

Define the rocks, add foreground water and add a little more drybrush pigment to the foggy area, swiping a little through the treetops.

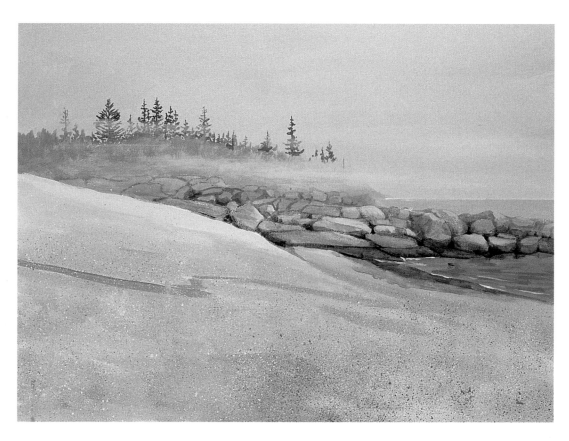

7) *Add Highlights*

The sun shines through the patchy fog to create dark and light sides on the rocks creating cast shadows. Use a dry brush to actually draw and scumble as you would if you were using charcoal. This contributes to the rock texture.

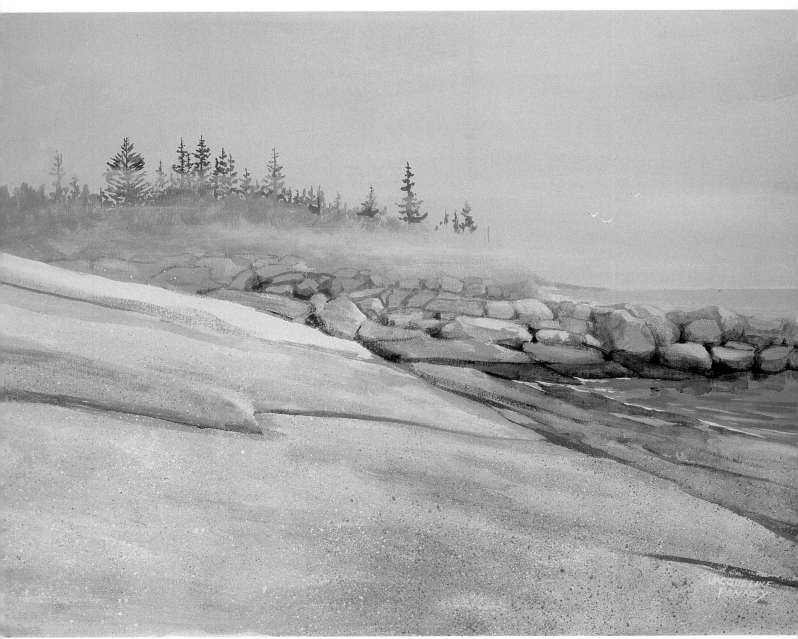

7) *Add Finishing Touches*

Glaze a mixture of Burnt Sienna and black over the lower right side, add a cast shadow on the slab, and make tide pools and more reflections in the water, and finally add three seagulls.

MAINE FOG
18" x 24" (46cm x 61 cm), acrylic on canvas

SAND, PEBBLES, ROCKS AND DEBRIS

ILLUSION

i would be considered a realist but not a photorealist. A photorealist is an artist who depicts a scene or still life so accurately it resembles a photograph. I like to create the illusion of realism and play with my paints and implements.

My earliest recollection of being awestruck by color was in kindergarten, when I accidentally melted a crayon on the hot radiator. I watched the crayon liquefy and melt down the radiator and I was transfixed. I added other colors and it made such an impression on my young mind that I have never forgotten the experience—and there are times when I try different techniques that I can relive, in some small way, that joy of spontaneity while creating. By the way, I never did finish kindergarten.

I used several tools and techniques to create the sand, pebbles, rocks and debris in *Rocky Beach*, such as a sponge, toothbrush, mask medium and a variety of brushes.

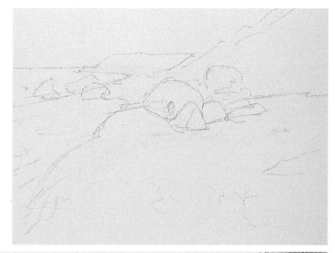

1) *Placement Drawing*
With charcoal, establish where the large beach area, some of the rocks, the distant land and the water are.

2) *Spatter*
Let's experiment with a different method for creating white stones and pebbles for this project. Protect a card table with paper and place the canvas down flat on top of that. Rather than use a soapy brush, use a palette knife to spatter the masking fluid. After dipping the palette knife into the liquid mask, gently tap the shaft on your other hand, causing droplets to spatter. The first few spatters are large. Make sure they go in the foreground area. As the fluid dissipates on the blade, tap a little harder to make smaller speckles. Allow the mask to dry thoroughly before proceeding. Paint a very watery light tone of blue-gray-beige over the beach area, and define the composition with light washes of local color so that you can better see the beach scene in its early stages.

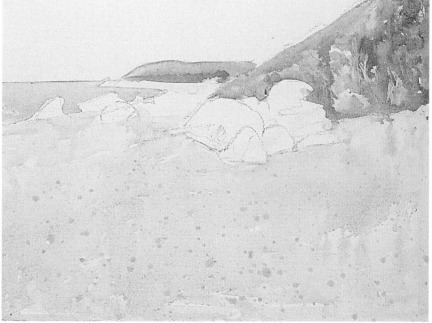

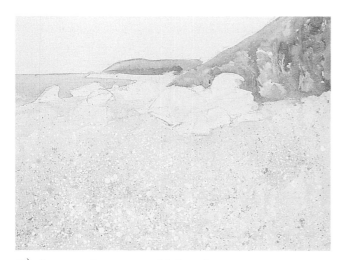

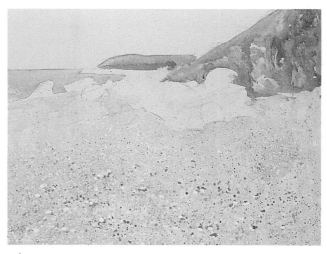

3) *Spatter, Spatter and More Spatter*

A toothbrush is a wonderful spattering tool and you can use it two different ways. The paint should be "soupy." For tiny spatters, flick the toothbrush with your finger sending a multitude of tiny flecks radiating in a broad area. Or load the brush and tap the handle on your other hand, the same way you used the palette knife, to make larger spatters. Regular brushes can also be used in this manner. Using all these utensils and techniques, mix puddles of paint and use them individually or mixed. The colors used here are Yellow Ochre, Raw Sienna and Raw Umber, blue, black and white. After the first application of multicolored spatters, allow it to dry. Remove the mask on the right side of the painting with a rubber cement eraser to see how it looks.

4) *Add Lighter and Warmer Spatters*

Mix very light, almost white, tints and continue to spatter. On a few of the foreground pebbles paint a bluish cast shadow to the right to make them pop out. Add more spatters using a blue-gray mixture. You want to do all of the major spattering before you begin to paint because the spattering makes a mess.

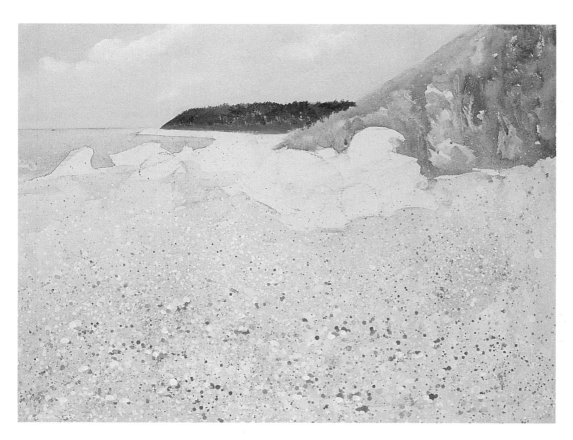

5) *Add the Sky and Distant Land*

Make the sky very light using a combination of Cobalt Blue, Phthalo Blue, orange, black and white. The distant land is painted by stippling with many variations of green.

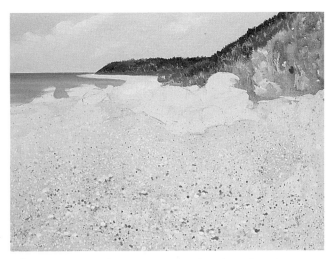 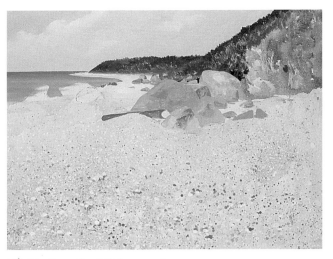

6) *Remeasure the Horizon and Paint the Water*

I cannot emphasize enough how important it is to have a perfectly level horizon line. Remeasure and re-mark it before you paint the water with a mixture of blue-gray-green hue that is a darker value than the sky. Use the ruler as a guide to make a crisp brushstroke.

The water has several values of blue that are brushed in with horizontal strokes. Paint the little cove and carefully paint around the rocks. Ordinarily you would paint right over the rocks and repaint them later, but for this demonstration paint around the rocks so that you can see where they are. Allow some of the underpainting to show through as you stipple the hill with several variations of greens.

7) *Define the Midground*

Defining the boulders is challenging because the colors and values are so close. The very subtle patterns and striations test one's perception. The dark background color is in sharp contrast to the lighter rocks and helps to bring them into sharper focus. Use a drybrush technique to create texture.

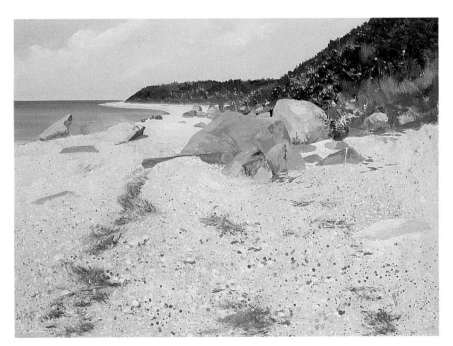

8) *Add Details and Debris*

Continue defining the rocks. Your palette will be covered in a medley of beiges. Because the hues and values are so close to one another, the edges need to be defined by value. This is called *chiaroscuro*, an Italian word meaning light and shade. The left sides of the rocks are light and the right sides are shaded. Complete the hillside by adding grasses and tiny yellow flowers. For the flotsam and jetsam on the beach, dip a small natural sponge into a mixture of Raw Sienna and white and drag it over the pebbles, creating irregular patterns that become wider toward the foreground. Brush in blue-gray shadows to the right of some of the debris to give a feeling of depth.

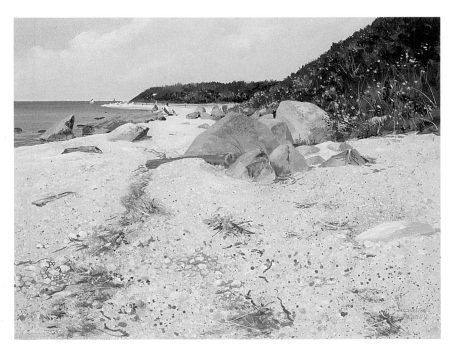

9) *Add Sailboats in the Distance*

Paint the distant beach almost pure white, add light green marsh grasses, sailboats and more debris in the foreground, and even little dots of bright color here and there. A glaze of Raw Sienna on the beach in a few areas gives it warmth without taking away from its whiteness. Yellow Ochre and Burnt Sienna glazes are applied on little areas of the hillside and rocks.

Calligraphy is generally applied to writing but may also be used as a painting technique. Using arbitrary brushstrokes to suggest something rather than define it allows the viewer to interpret what those strokes mean while giving life to an otherwise dull area of a painting.

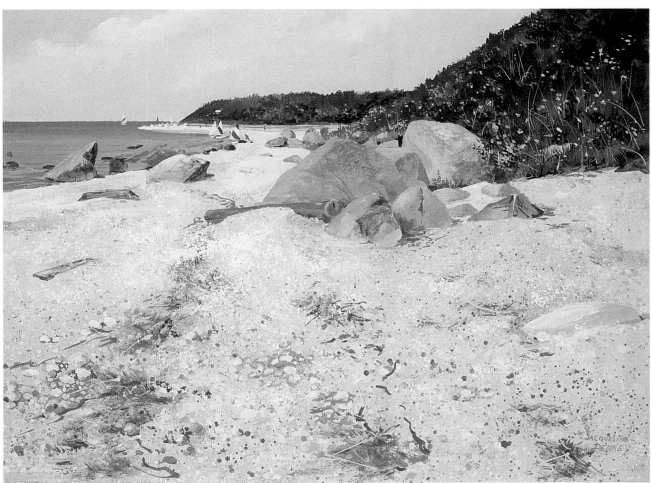

10) *Make Last Minute Decisions*

Spritz a little more white on the midground beach with the toothbrush. Add one more sailboat and stipple more white in the foreground using a sponge. The organic rock shapes and undulating beach are dominant; the subordinate diagonal shapes of the hillside and debris add excitement and interest, luring the eye into the distant activity of the triangular sailboats.

ROCKY BEACH
18" x 24" (46cm x 61cm), acrylic on canvas, collection of Catherine R. Seeley

DEEP SWELLS

EXPERIMENTATION

i painted the next two paintings using very different techniques and pigments. *Close Company* was lightly underpainted with acrylic paints to compose the scene, and when it was dry I painted over the acrylic underpainting with Winsor & Newton Griffin Alkyd Color. Although it dries faster than regular oil paints, its blending capabilities last longer than acrylics—I wanted to experience the difference. I am told that it is not wise to put an oil-based pigment over a water-based pigment, but my temperament allows me the freedom to enjoy the process more than the product.

For the choppy water and rocks in *Before the Squall*, I used a palette knife and modeling paste to create texture before I painted it. Unlike *Close Company*, this painting is completely executed with acrylics. I used opaque pigments and glazes, and scumbled white over the modeling paste in the water and rock area.

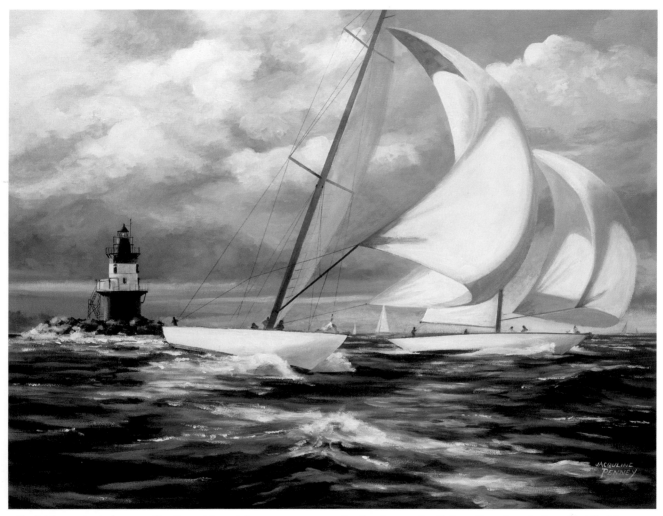

The lighthouse stands tall, erect and solid, emphasizing the swells in the water, which are angular and energetic.

The diagonal lines of the mast, rigging lines and stays repeat the angular thrust of the turbulent water and intensify the motion of the boats.

I painted over a detailed acrylic underpainting with Alkyd fast-drying oil paints to blend the clouds, glazed deep colors over the water and scumbled white pigment on wave crests.

CLOSE COMPANY
22" x 28" (56cm x 71cm), oil over acrylic, collection of the artist, print available from Aaron Ashley, Inc.

CHOPPY WATER

PROJECT **8**

The tilt and angle of the sailboat in juxtaposition to the clouds, the rough water and the waves crashing on the rocks summon excitement and action.

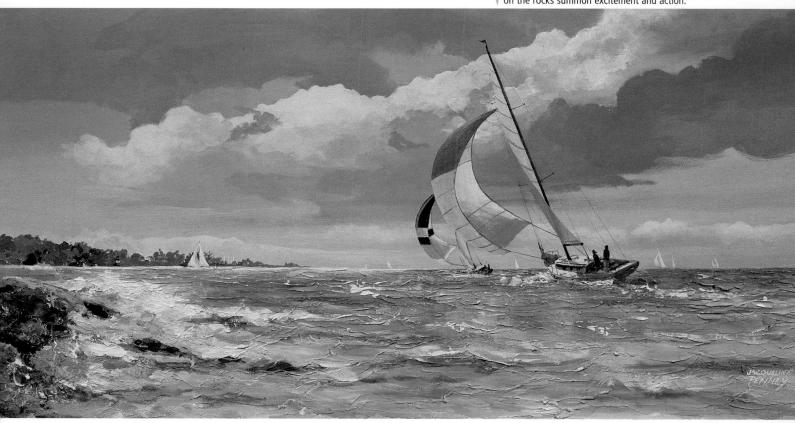

I used a palette knife and modeling paste to create the texture of choppy water. When it was dry, I painted the water with opaque pigment, glazes and scumbling to create the turmoil of the water.

BEFORE THE SQUALL
15" x 30" (38cm x 76cm), acrylic on canvas, collection of the artist, print available from Aaron Ashley, Inc.

The wake, the direction of the sailboat and the angle of the cloud formation lead the eye into the painting, the distant land and the small boat, and then down to the crashing waves on the rocks, creating a circular movement.

lighting, still lifes and interesting props

Our artistic interest is captured by what we see. Is it the lighting, location, human interest or structure? Does it have something to do with the weather? Is it a challenge to create your own lighting on a still life, to make it personal and different? Is it wanting to improve the composition of a particular scene—or even change the weather—that makes us want to capture anew, something we saw or felt? The what, where, when, why and how are all determined by the artist—the artist's distinct, personal and individual action of creation.

This chapter explores shadows and reflected light, taking objects large and small and creating something more, something seen in the mind's eye. The use of personal objects in a still life lures the artist's attention away from the ordinary. The still life becomes a stage where the artist sets up an assemblage of meaningful and complementary objects, plays with the lighting and pushes toward the extraordinary.

Grandma's Pitcher and Lace *was painted from the still life setup without using the aid of a camera. I didn't have to worry about the flowers because they were dried, and because it was a slow season I had the opportunity to spend lovely long hours connecting to my past. I remember watching my grandmother crochet doilies hour after hour. It was not a chore for her, nor was it a chore for me to paint it.*

GRANDMA'S PITCHER AND LACE
22" x 28" (56cm x 71cm), acrylic on canvas, collection of the artist

INTERESTING INTERIORS

the inspiration for *Spruce Head Island* was a typical rustic fishing shack in Maine that was actually painted barn red with white trim. I did a demonstration for my watercolor class using a photograph of the fishing shack for reference and decided to make the building white. I wanted to illustrate the process of leaving large white areas, and the end result was very pleasing, so much so that I decided to paint a similar scene on canvas using acrylic paint. The subject was appealing, but what really interested me was the huge contrast between the eye-squinting, bright, white façade and the warm mysterious interior beyond the doorway.

An open door is an invitation that beckons to us to peer across the threshold, to explore and to imagine what is inside this unfamiliar place. I took advantage of the door and window and used those two rectangular formats to create miniature paintings within the subject. I added windows inside the room that pull the viewer further inside to look out and beyond.

Making slight modifications to the building, changing its color and adding artistic interpretations enhances the actual scene. I think the composition of *Spruce Head Island* is the primary reason why I won a cash award for best landscape in a national competition. I am very proud of this painting and explain why I think the composition is successful at the end of the demonstration.

The mini demonstration illustrates my process of painting a doorway and window and how I mix beautiful darks and bright whites, paint cast shadows and make use of silhouettes.

1) *Prepare*

To illustrate interesting interiors we'll duplicate a small section of my painting *Spruce Head Island* and learn how to paint doors and windows. In preparation, paint the canvas with a very lightly tinted mixture of Yellow Ochre, orange and white, so that the building's façade is a warm, sunlit white.

Replicating manmade structures requires accurate measurements and proportions. When the background is dry, measure the door and window openings carefully, lightly draw the shapes with pencil and add another rectangle for the interior window. Mask around the outside edges of the interior window and paint it a light blue/gray sky color, adding shapes near the bottom that represent distant trees.

2) *Mix Warm Darks*

When the sky color is dry, mask off the inside edges of the window and the outside edges of the door and exterior window so that you can paint freely without worrying about losing the sharp edges. To make dark values, basically use all the dark colors on your palette, creating warm hues, and paint patchworklike brushstrokes in the masked-off area. At this stage don't think of any recognizable shapes within, just beautiful warm darks on which to create interesting shapes as the painting develops.

3) *Add Familiar Shapes*

Remove the tape from the interior window and add familiar shapes inside the building, such as bottles, containers, a pail and a diagonally placed rod that could be a mop, a broom or a piece of wood. The exterior window may reflect the sky or another building. Paint some light blue as well as dark colors. Remove the tape from around the window but not the doorway.

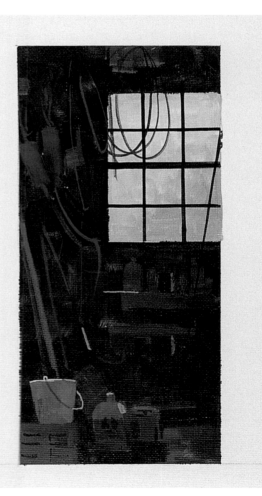

4) *Add Window Mullions and Objects in Silhouette*

Measure accurately where three vertical mullions are to be placed, marking the top and bottom of the interior window; measure where the larger horizontal crossbar is in the middle of the interior window and add a mullion above and below the crossbar.

With a well-loaded liner brush and using a yardstick to steady and guide your brushstrokes, paint the dark mullions that are in silhouette. With the same brush make several circular strokes to simulate rope or wire hanging above the window, add bottle shapes on the windowsill and add more shapes and colors inside the room.

Measure the mullions on the outside window and, using the same warm white as for the preliminary façade color, paint the mullions the same way you did for the inside window.

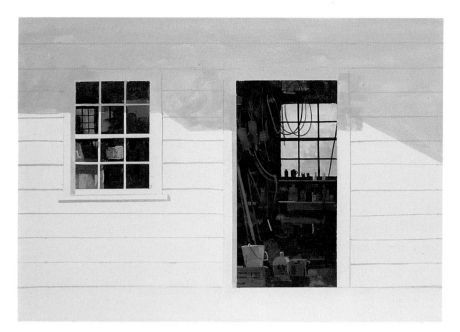

5) *Paint the Cast Shadows and the Clapboard*

Measure and lightly draw with pencil the window, doorframes and shadows. Then mask the shadow areas around the left sides of the door and window, and the diagonal cast shadows as well. Paint the shadows with a mixture of Cobalt Blue, Payne's Gray and white, adding a tiny bit of orange and red to give it warmth—not a lot, just the tiniest amount. Mark where the clapboards are on both sides of the painting. Using the same shadow color, load a liner brush and paint the clapboard, using a yard-stick to steady the brush. Paint vertical lines to the right of the door and window frames.

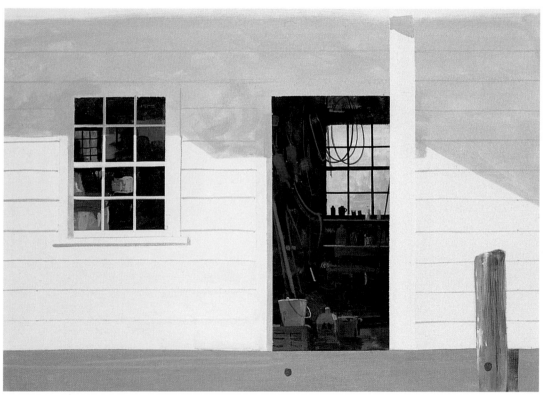

6) *Add the Dock and the White Column*

The darker color of the dock and piling requires one coat of paint, but the white column needs four coats to cover the dark. Mask off the column and paint four coats of pure white pigment on the column, drying the area thoroughly with a hairdryer between coats.

The red of the buoys is repeated discreetly in the "ice" lettering that the railing divides, and again in the bucket and flowers above.

The predominant *Z* shape of this composition connects the white areas via the handrail for the steps.

The brilliant whiteness of the building and boats contrasts with the softness of the foggy backdrop and the velvety water.

The large ladder is partially repeated on the other side of the dock in silhouette.

The pillars allow for an unseen roof that creates shadows on the building, breaks the monotony of the windowpanes and gives a feeling of depth to the deck area. The vertical shapes are repeated throughout the painting with pilings of different lengths.

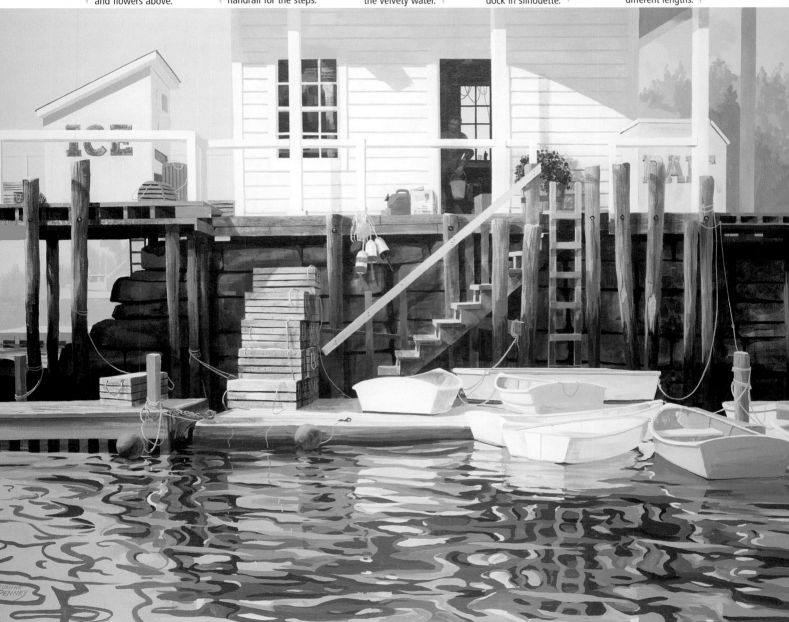

The repetition of obvious shapes, large and small, unites the subject information. For example, the diagonal shape of the steps is repeated in the angle of the icehouse roof, in the shadow on the building; in the ends of the bait box and even more subtly in the shadowed rocks under the dock.

The steps lead the eye into the shop, to the shadowed figure and beyond through the window.

SPRUCE HEAD ISLAND
36" x 48" (91cm x 122cm), acrylic on canvas, collection of Judi and Bill (Wilber) Osler

WHITE ON WHITE

began a series of still life paintings inspired by a collection of white enamelware, linens, lace and interesting objects I have on display in my studio. It is a challenge to paint white on white because of the close values and tints. When I was teaching my weekly classes I used the white enamelware to illustrate those subtleties. I asked the class, "What color is this coffee pot?" and the answer was always "white." Then I asked them what color the highlight is. This always produced an "aha" look and I would continue asking them what they saw when I placed other objects nearby. You could almost hear the cognitive switch from left-brain to right-brain mode as described in Dr. Betty Edward's book, *Drawing on the Right Side of the Brain*. They stopped thinking and started *seeing*; realizing that white is never just white.

PHOTOGRAPH YOUR STILL LIFE

I set the first lace and white porcelain still life on a table under a skylight. The sun became a spotlight creating beautiful shadows, but the shadows kept moving. I took my time with the drawing and didn't worry about the sun's position. I drew directly on tracing paper that was firmly attached and registered to my canvas so that I could eventually paint in stages, accessing the light and shadow patterns when they were available. I forgot that every day isn't sunny. On those days I made corrections or went on to something else. The still life was set up for ages, but eventually a painting evolved.

The next time I set up a still life I made some changes in the process to save me time and frustration, changes that would even allow me to paint on rainy days. I took slides of the setup from several angles, sent them to an overnight photo processing center and had them back the next day.

PRESERVE YOUR DRAWING

When teaching watercolor I devised a technique to help students reserve their whites—which is so important in watercolor painting—and to keep the paper clean. I found it easier to have them draw on tracing paper. It allowed

them to erase and make corrections without being concerned about smudging their clean paper. It also gave them more freedom to lay in washes within established boundaries and to experiment with color technique without getting "lost." It gave them time to plan and prepare the next step because the drawing was always available, firmly attached to the backing board and registered so that it was always exactly in the right place.

When painting detailed still lifes and scenes in acrylic, you can use the same technique and draw directly onto tracing paper affixed to your canvas. The drawing remains constant and the painting develops in stages without fear of losing the drawing.

TO DRAW OR PROJECT?

You may be an accomplished artist who enjoys the process of freehand drawing, or a beginning artist who does not find drawing easy or rewarding. I offer you another possibility. Project the still life onto the tracing paper already attached to your canvas. This allows you the freedom to move the image around on the canvas, enlarging or reducing it to make an interesting composition. The projected still life gives plenty of light in a dark room, enough to draw the objects onto the tracing paper.

The slightest movement of your canvas or projector will cause distortion and make it difficult to find the exact place again, so mark the position of your projector and easel just in case they are dislocated.

FREEDOM OF BRUSHSTROKES

In the *Sunshine and Old Lace* demonstration, I trace the outline of the white eyelet doily on the canvas using transfer paper. This just shows me where it is on the canvas. Then I fold the tracing to the back of the canvas and paint the doily. The brushstrokes are not restricted to the linear boundaries but may flow beyond them, unbroken and fluid, allowing me to concentrate on the subtle tints, shadows and textures of the doily itself. The tracing is then brought back over the canvas, when it is dry, and the doily is retraced.

how to photograph a still life

Use natural or artificial lighting above the objects that shines slightly to one side to create distinctive and pleasing shadows. Change the position of your camera and shoot from several different angles, moving objects if necessary using your viewfinder to create an attractive composition. Bracket your exposures, going up one half-stop and down one half-stop as a safety precaution, giving you a choice of exposures. If your still life includes flowers or perishable foods, record it on film and capture them at their peak of freshness.

Slides or Prints * If you intend
to draw directly from the still life, prints are adequate for reference. If you are more interested in painting than drawing, you might want to use slides so that the image can be projected. A failsafe way to accomplish this is to attach tracing paper to your canvas, cutting it to size on the bottom and both sides. The top needs to be a little longer so that it can be folded over the canvas and taped securely to the back. I staple over the tape to fix it even more securely.

Register Marks * When the tracing paper is firmly attached on the top of the canvas, tape it on the two lower edges, being sure that it is taut. Make two pencil lines on each side that mark the tracing paper and the canvas at the same time so that the drawing will be "registered": It will always be in the exact place each time the tracing is brought forward, matching the lines on the tracing with the lines on the canvas. Project the slide of your choice onto the tracing paper in a semidark room and trace using pencil. This technique makes it possible for you to paint in stages, tracing a few areas at a time on the canvas, painting areas that are underneath objects, tracing the objects and then painting them. This technique makes the painting look more spontaneous and less like painting by numbers, which is what happens when you trace directly onto the canvas.

1) *Project or Draw a Still Life*

Set up a still life on a tabletop placing the objects on a doily that hangs over the edge of the table. The part of the doily that hangs over the table will be more prominent and show lovely detail. The part that is lying on the table is distorted because of perspective.

Either draw the still life in detail from life or photograph the still life and project it on the tracing paper that is affixed to your canvas. Then, using transfer paper, trace just the outline of the doily on the canvas to show you the area that will be painted white.

2) *Paint the Doily*

The lightest part of the doily will be in direct light that shines on the table; the overhang will be in shadow. Mix white with Yellow Ochre and a little orange to make it a warm white and paint the doily that rests on the table. Then add a little blue to that mixture. Use Payne's Gray and a touch of red for the shadow area that hangs over the edge of the table. After the values have been established, utilize the texture of the canvas to give the illusion of linen by drybrushing a little lighter mixture over the shadow area, picking up the nubbiness of the canvas. Do not worry about staying within the boundaries of the doily. Allow your brushstrokes to be continuous and more fluid. The edges will be reestablished by tracing the doily again.

3) Retrace and Paint

Retrace the doily and the other objects using transfer paper. The color of the cloth on the table is your choice. Use a warm pink-mauve made by mixing several reds with orange, greens, blues, Payne's Gray and white. For the darker area use Phthalo Blue, Phthalo Green, several reds and Burnt Sienna with a little Yellow Ochre to lighten it. Use a 1-inch (25mm) square tip brush to cut around the edge of the doily, using the side of the brush to get into the v-like notches. Painting the negative space between the pots establishes their form.

4) Trace the Details and Paint the Shadow

When the paint is dry, bring the tracing paper back over the canvas, matching the register marks, and trace the details of the doily and its cast shadow on the cloth. Use white transfer paper to trace the handle of the pitcher on the left because it is in a dark area and the black transfer paper will not show up.

Use a slightly darker mixture of the table covering and paint the cast shadow, leaving the small roundish areas created by the holes in the doily. The holes on the doily that hangs over the edge of the table are filled with the same shadow color, maybe even a little darker. The eyelet holes on the table are a lighter mixture.

5) Use White On White

The stitching around the eyelet is thicker; so to give that illusion, paint pure white pigment around the holes and the edge of the doily. Adding a slight shadow color on the lower portions of the stitching also brings out the thickness.

SUNSHINE AND OLD LACE
22" x 28" (56cm x 71cm), acrylic on canvas, collection of the artist

SHADOWS AND REFLECTED LIGHT

CHANGING THE SEASONS

*t*he cast shadows under the eaves and the warm reflected light in the turret—even though the building was neglected, cold and austere looking—drew my attention to this Victorian house. Using the basic structure, I decided to create another reality for this once–beautiful home in another place and time.

I took the photograph in late fall, but there was nothing to stop me from placing this lovely old building in warm, sunny, early summer surroundings. I became the interior designer, housepainter and landscape architect. I gave the door and windows a new look. I placed an old wicker rocker on the front porch and even hung out some laundry to make it homier. I now find it very inviting.

The image of the house is projected onto tissue paper that is overlaid on the canvas and drawn in detail. The tissue paper is firmly attached and registered so that each time it is brought forward the register marks will ensure it is always in the same place. Refer to the sidebar "How to Photograph a Still Life" on page 79 for more details.

I traced just the outline of the building using transfer paper. Then I folded the tissue paper to the back of the canvas and proceeded to paint the sky and distant trees. I didn't worry about brushstrokes going into where the house will be.

When the paint dried, I overlaid the tissue paper drawing and traced the house in detail, except for the windows and the cast shadows. They were redrawn later.

I painted the house a mixture of warm white (white, Yellow Ochre and orange) and the roofs a variety of gray-blues, paying special attention to the change of value on the turret's angled dome.

When that was dry, I traced the cast shadows under the eaves and turret.

The cast shadow under the eave is a cool bluish color, but the filigree holes are a warm dark tone, as are the attic windows. It was easier to paint the crossbars on the window after the whole window was painted.

The porch under the turret is filled with warm reflected light, a mixture of many warm colors softly blended

Reference Photograph

together to give interest and is the focal point of the painting, having the most detail.

The lower porch is also filled with warm reflected light that is justified by the flowering shrubs. I painted the whole area with a variety of strokes and warm colors, disregarding the windows, posts and door. This allowed me more freedom.

I traced the windows and shutters, but not the crossbars. I painted the curtains showing light and shadow and defined them by painting the interior a variety of warm darks. Perhaps a red chair is near the window or a lamp. The lower windows may be reflecting light from the garden as well as the interior of the house and curtains.

When the windows were dry, I painted the crossbars. The windows in the sunshine have warm white bars, and the windows in the shade are a bluish-white.

I continued painting in the details of the posts, side porch, steps, chair, laundry in the side yard, the chimney and the cast shadows on the roof.

I used my imagination or other resource material to paint the trees, garden, lawn and foreground.

The decorative filigree on the Victorian house is repeated in the lacy leaves and dabs of color in the shrubbery.

The distant landscape is muted, enhancing the dominant structure.

The windows sparkle with reflections and glimpses of the interior of the house treatment on the front porch.

Laundry hangs on the line, a wicker rocking chair sits on the porch and you are invited to knock on the door because you know someone is home.

MONDAY
48" x 60" (122cm x 152cm), acrylic on canvas, collection of Dr. and Mrs. Raymond Fox

The surreal pathway of muted colors, directional brushstrokes, the garden and the tree branches all draw the viewer toward the house.

INTERESTING PROPS

*h*ere is a group of still life paintings that incorporate a variety of different props to create interesting and intricate scenes. All of the techniques we've discussed are used in one or more of these paintings. Look around you. Let your imagination go. Arrange and rearrange props until you find a grouping that expresses your own ideas.

Dancing in the Light is a painting in my series of still lifes using small wooden artist's mannequins. They bring a surreal atmosphere to the setup without detracting from the delicate colors of the antique electrical insulators and the cast shadows, which enhance the feeling of movement. The dark area below accentuates the tabletop, creating a stage on which the dancers can dance.

DANCING IN THE LIGHT
15" x 30" (38cm x 76cm), acrylic on canvas, collection of the artist

Gifts from Mom was an arduous endeavor because of the intricacies of the antique jacquard blanket and lace. I took a slide of the blanket and lace and projected it onto tracing paper affixed to my canvas. It allowed me to work in stages, making a difficult task easier. The other objects were painted from the setup. The composition pleases me because of the repetition of shapes. The oblong shape of the jacquard blanket is repeated in the painting behind the pitcher and the basket. Circles and ovals are repeated in the decorative plate, doily, cup and the curving stitches in the blanket as well as the flower blossoms.

GIFTS FROM MOM
22" x 28" (56cm x 71cm), acrylic on canvas, collection of the artist

I think at some time in an artist's life the challenge to paint white objects on a white background becomes too irresistible not to try— and becomes an enjoyable task.

WHITE ON WHITE
22" x 28" (56cm x 71cm), acrylic on canvas, collection of the artist

Linen, Lace and Ginger Jar *uses an old plant stand with strong ver-*
tical lines as a base for the still life. I did make use of my camera for
this detailed still life. The diagonal bar is repeated in the sidebars as
well as the soft angular drape of the lace tablecloth on the left.

LINEN, LACE AND GINGER JAR
22" x 23" (56cm x 71cm), acrylic on canvas, collection of the artist

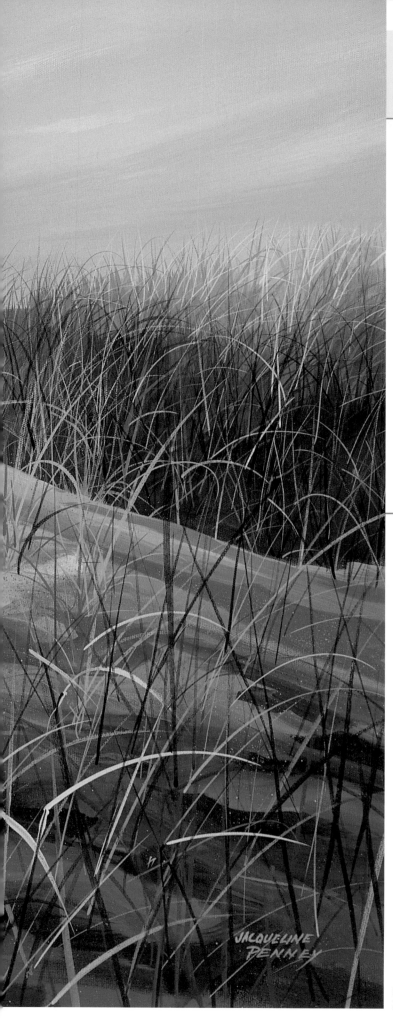

five

putting it all together on various grounds

This chapter contains four complete demonstrations on different grounds: Two are painted on stretched canvas; one on illustration board, which is similar to watercolor paper, and one on already-primed Ampersand Gessobord purchased in an art store.

This last chapter touches briefly on some of the possible grounds on which to paint that show by example the versatility of the acrylic medium. Each deviation from your usual painting routine not only affords more experience but also oils creative machinery that may have lain dormant too long. Take advantage of all the tools at your disposal, not only painting tools but also photographs, copy machines and projectors.

SAND DUNES
24" x 30" (61cm x 76cm), acrylic on canvas, collection of the artist

"SAND DUNES" ON CANVAS

IN MY DEFENSE

*t*he first thing I'm going to do is make excuses for myself. Ordinarily I paint very quickly and am able to blend colors with ease, stopping when it suits me. For the purpose of these demonstrations I stop to photograph each step and because of this, the paint dries, making blending the way I ordinarily do impossible.

THE GOOD NEWS

However, I have learned to compensate for interruptions by remixing my pigment as closely as I can—but it is never exactly the same. I find that this is actually to my advantage, because each time I change my colors the painting becomes more interesting. Drybrushing to blend also helps make a soft transition from one hue to another.

THE PROCESS

Breaking my creative process down into a series of steps is no easy job. It would be much easier to make a video so that you could watch every brushstroke. However, this is a how-to book, and the advantage of being able to take time to think about what I am doing is also to my advantage. For instance, I had an insight while painting *Sand Dunes* that I will share. It's about fear. I have had many people tell me that I make painting look easy. After years of practice, it has actually not only become easy but a joyous experience, and I have confidence that I can produce. However, I know that what I demonstrate with so little effort does not come easily to everyone else. I love the creative process and I have overcome my fear of making mistakes of ruining what I have done by making changes or trying to please someone else.

UNDERSTANDING PAINTER'S BLOCK

Perspective gives us the illusion of depth on a two-dimensional surface. Distant objects are made to appear smaller and foreground objects larger. Overlapping enhances the depth even more. The demonstration of painting the sea grass and sand dunes requires overlapping brushstrokes, crisscrossing, bending and twisting to give the illusion of windswept dune grass. My insight is that, for many, this produces fear, particularly when something must overlap a previously painted area. I understand that fear because, as they say, I've been there, done that. The fear of ruining an area so carefully painted by overlapping is legitimate, but it paralyzes the creative process. My advice is simple: Feel the fear and do it anyway. Creating depth on a canvas is a process similar to life: We do not acquire true depth in life without taking chances and being bold, brave and adventuresome. And more good news! So what if you make a mistake? With acrylics you can paint right over an area and begin again. If you enjoy the process of painting, don't worry about the product until you master the technique.

This is my reference photo.

This is the reference photo scaled to size. This is in the proper proportion to a 24" x 30" (61cm x 76cm) canvas.

1) *Begin with a Charcoal Sketch*

Measure approximately one-third of the way down from the top of the canvas, or 7½" (19cm), and make a mark on both sides. Then draw a perfectly level horizon line. You can make compositional adjustments by creating interesting passages that allow the eye to roam around this simple subject. For instance, make the dune grass higher on one side than on the other and emphasize the expansive sand dune with shadows that create triangular pointers to the sailboat.

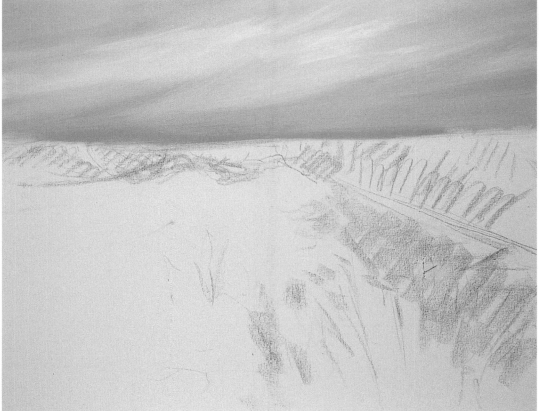

2) *Paint the Sky*

Paint the sky using subtle shades of blue/gray. Make the sky darker toward the horizon. Disregard the grass area and paint over the sketch, bringing the sky down below the horizon line. Brush in the clouds with sweeping motions from left to right giving them an angular thrust; this will help create action in a somewhat placid scene.

Clean your brush and make a light mixture of Yellow Ochre and white. Bring the sand dune up by painting over the bottom of the grasses. This visually pushes the grass onto the other side of the dune. The light sand color picks up the wet paint underneath and gives it a greenish tinge that will be corrected in the next step.

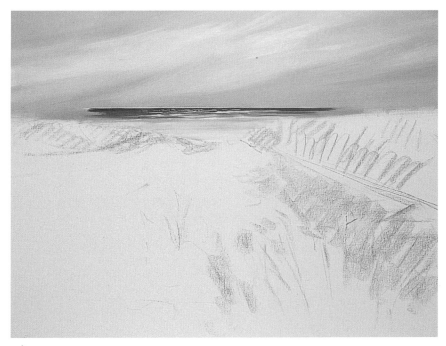

tip Determine what range of values you want. If you want lighter values to predominate, start with a lighter pigment such as yellow and work the other colors in gradually. If you want darker values, begin with the darker pigments, such as the umbers and greens, and work in the lighter ones.

3) *Reestablish the Horizon Line and Paint the Water*

Measure down 7½" (19cm) again on both sides and lightly redraw the horizon line with pencil. Because the sky is darker near the horizon and the water is also dark, an interesting contrast is to make the distant horizon light. Using a yardstick to steady the brush, paint the water using combinations of Phthalo Blue and Phthalo Green, Payne's Gray and white. Add more white to the mixture toward the shoreline.

Using a small round brush and white paint, steady the brush on a yardstick and paint the breakers horizontally in various thicknesses. If the water area is still wet you can pick up some of the color underneath, softening the waves. The waves can be repainted with white when dry to give more contrast, and should be parallel with the horizon.

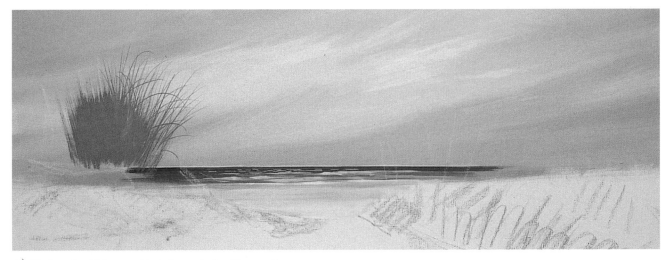

4) *Paint the Distant Beach and the Dune Grass*

With a small square-tip brush, paint the beach with a mixture of Yellow Ochre, a touch of red and white, adding a little blue for slightly darker areas, making subtle changes in this small area. With a 1½-inch (38mm) bristle brush paint several upward sweeps of a medium green by mixing Hooker's Green with Payne's Gray, Ultramarine Blue, Raw Sienna and white. Extend the grasses into the sky area using a medium–size rigger brush amply loaded with the same mixture.

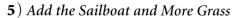

5) *Add the Sailboat and More Grass*

The windblown clouds establish that the wind is from the left. It is important to research how a sailboat looks with the wind coming from that direction and how it fills the sails.

Continue painting the grass using the color and technique described in step 4. Then add more Payne's Gray and Burnt Umber to that mixture to make it darker. Repeat the grass-making technique over and to the right of the first clump of grasses. Continue this procedure to create interesting greens that overlap one another. Add more grasses, remembering to create contrasts by making light strokes over dark, warm over cool and vice versa. Varying brushstrokes are of utmost importance. Experiment with as many variations of green as you can by mixing various combinations of Burnt Sienna, Burnt Umber, any green, Yellow Ochre or Cadmium Yellow.

6) *Practice Light Over Dark*

Add Yellow Ochre to your green mixture to lighten it and switch to a 1-inch (2.54mm) square-tip brush and repeat the process, again finishing off the grass by extending it with a rigger brush.

7) *Correct the Sand Color*

With a mixture of Yellow Ochre, white and a little Burnt Sienna, repaint the top of the dune, adding a small amount of Cobalt Blue nearing the shadow to the right. To make the shadow darker, add more Cobalt Blue and Burnt Sienna. The reddish color of Burnt Sienna will make a purplish color when mixed with blue.

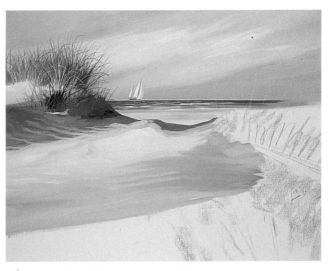

8) Mingle Shadows with the Grasses

Overlap a clump of grass in front of the other grasses and dune to add depth to the scene. The sunlight comes from the same direction as the wind, creating shadows to the right of the grasses and dunes. Using the same shadow mixture on the palette, add Naphthol Crimson to create a dark lavenderish hue and bring it up into the base of the grasses for a gentle transition.

Lighten the shadow color and extend it to the left. Quickly mix a light sand color with Yellow Ochre and white and paint it below and to the right of the shadow. While the area is still wet, use the side of the 1-inch (25mm) square-tip brush to stroke the sand color into the shadow color. Twist the brush in your fingers to vary the thickness of the brushstroke.

9) Blend Shadows and Ripples

While the pigment is still wet on your canvas, continue applying variations of shadow color with sand color to create soft ripples, blending one hue into the other without losing the ripple effect.

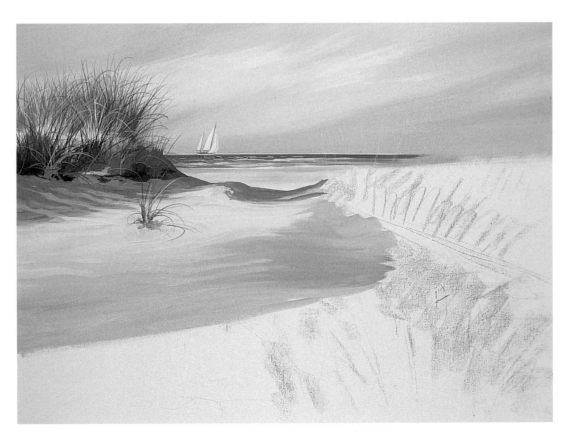

10) Add More Grass

Add a darker value of green grass above the shadow, extending it with the rigger brush up into the other grass. With just the rigger brush, stroke in several light blades of grass in the sunny area on the dune, and use the same shadow color to cast its shadow on the sand.

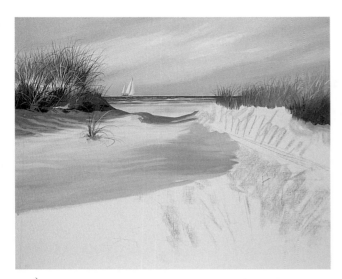

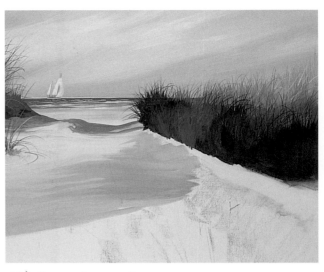

11) *Add Brighter Grasses on the Right Side*

The sun shines brightly on the top of the grass area on the right, and the green needs to reflect that sunny glow, mixing variations of yellow-greens. Mix several varieties of greens and continue creating this large patch of dune grass as before. Allow a little of the blue water to peek through to heighten the depth.

12) *Create Strong Contrasts*

The strong contrast between the sunlit tips of grass and the silhouette grasses in front adds interest. The dark greens are made using a variety of colors, not just green and Burnt Sienna, for instance, but reds, oranges and blues. This will create a base for lighter grasses to be applied, adding interest.

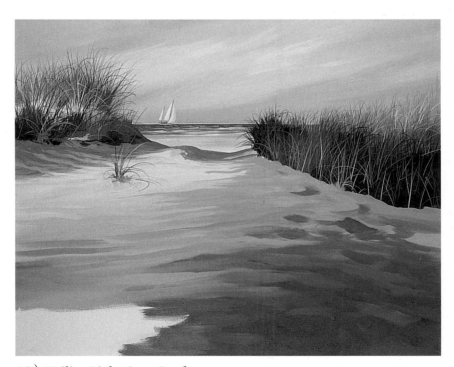

13) *Utilize Light Over Dark*

Mix a variety of lighter greens to go over the interesting shadowed area of grasses. Create a variety of shadow colors to be interlocked with the lighter sand color as you paint the rest of the dune area, continuing to make ripples and crescent-shaped shadows that simulate foot impressions in the sand. I used many variations of colors such as Payne's Gray, Naphthol Crimson, Phthalo Blue, Phthalo Green, Cadmium Red, Cobalt Blue, orange, Yellow Ochre, Raw Sienna, Ultramarine Blue and white.

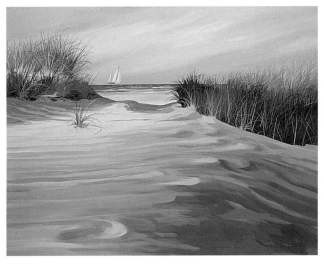

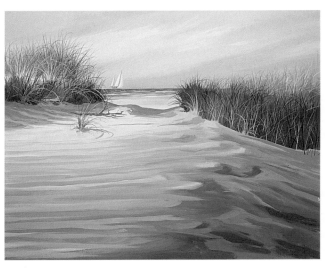

14) *Introduce Bold Colors*

Introduce a more distinctive Phthalo Blue in the triangular shadow area in the foreground to connect it to the color of the water.

15) *Add Glazes*

Now make decisions as to how to pull the painting together. I felt the large crescent shape in the foreground was too distracting and painted over it. In preparation for adding glazes over the grass area on the left and right, add almost pure white blades of grass using the rigger brush. Also add a gnarled root in the upper left.

With a 1-inch (25mm) square-tip brush, mix a watery solution of Yellow Ochre and a small amount of matte medium, which gives the mixture more substance, and apply it to a portion of the grass area on the left. Also glaze that area using Raw Sienna and Burnt Umber in the same manner.

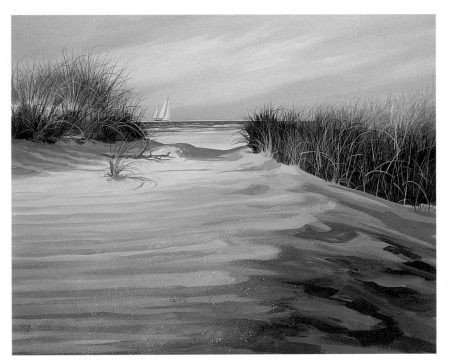

16) *Create Interesting Sand*

Add greenish/bluish colors to the shadow area, repeating the colors in the background. Using several combinations of colors ranging from light warm colors to dark cool colors and vise-versa, spritz the dune area using a toothbrush. Wipe up any specks that go into the grass area.

Add more intense glazes on the right dune grass area, and balance it on the left by adding more glazes to that area as well.

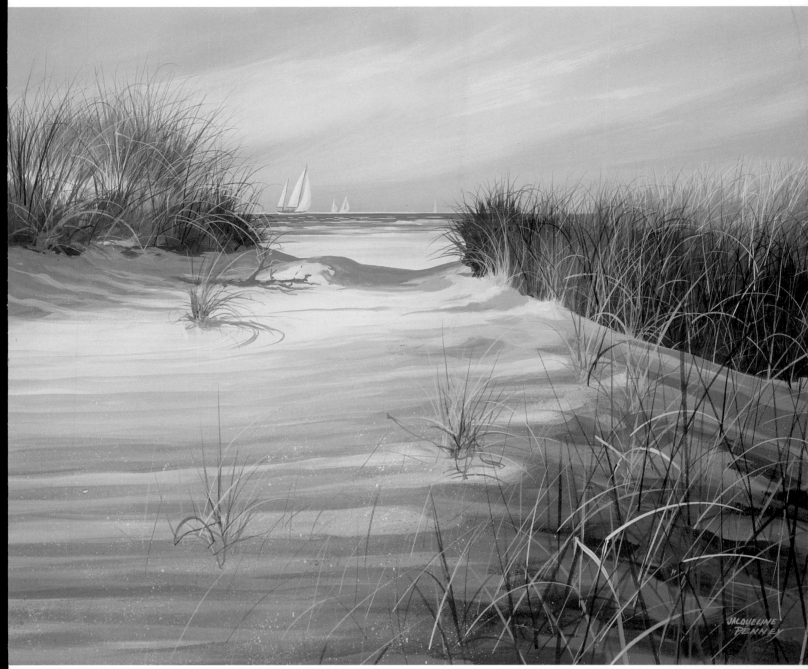

17) *Add the Finishing Touches*

With a large no. 6 rigger brush, paint in the large foreground grasses using your whole arm in one continuous sweep of color. Much of the grass is in shadow and is quite dark; however, the tips of grass pick up the sunlight and are very light. I felt the grass area on the upper right needed to be mowed down a trifle, so I mixed some of the sky color and brushed it over the tops of the grass, pulling the sky color down into the grass the way I pulled the grass upward into the sky. It needed two coats to cover the grass strokes. And my last decision was to add a few more sailboats in the distance.

SAND DUNES
24" x 30" (61cm x 76cm), acrylic on canvas, collection of the artist

"MOUNTAIN WILDFLOWERS" ON ILLUSTRATION BOARD

INSPIRATION

When I was in Colorado on a painting holiday—the happy recipient of a watercolor contest given by *Watercolor* magazine and the Forbes Foundation—I had the rare opportunity of painting almost anywhere in a 250-square-mile radius, with guides to provide all the necessities for safety and comfort. I did several paintings on location and took several rolls of film for future use. This demonstration illustrates how I used that reference material. The end result is not a copy of the photograph: It is a combination of several subjects, arranged creatively into a pleasing composition.

Mountain Wildflowers was painted upright on illustration board, and gravity caused the colors to run downward. I like the effect because the pigment automatically blends and mixes together, creating variations of value and hue, puddling in some areas that are not wet. When it reaches a dry area it stops as if by an invisible force. However, if too much water is added, the weight of it will cause the paint to drip into any dry areas below. Unlike watercolor, this pigment is permanent when it is dry. Lifting color out is possible only when it is newly applied. The advantage of acrylic paints is that you are able to paint crisp opaque tints and colors on top of any area when it is dry.

tip

Preparing Illustration Board

To prevent warping when using transparent washes on illustration board, paint the back with matte medium and allow it to dry. Create a wide border by laying strips of housepainter's tape along the edge to keep it clean. Because the housepainter's tape does not stick very well, lay masking tape ½" (1.27cm) over the inside edge. This makes a nice crisp border in case you want some of it to show when you have the painting matted and framed. The other advantage is tjhat when the painting is completed you can see how it will look with a mat around it and make adjustments if they are needed.

1) Draw the Basic Shapes and Begin to Paint

Lightly draw the shape of a rock and a few lines to show where large clumps of flowers are going to be, and paint the Indian Paintbrush wildflower. Use a medium round-tip brush and paint directly on the dry surface, using transparent combinations of reds, oranges, Yellow Ochre, Raw Sienna and Burnt Sienna.

2) *Underpaint Wet-in-Wet*

With a 1-inch (25mm) flat brush, lay in very wet transparent washes of muted colors on the rock, painting around the flower, and quickly change to a medium round brush. Add more color into the wet areas and allow them to blend.

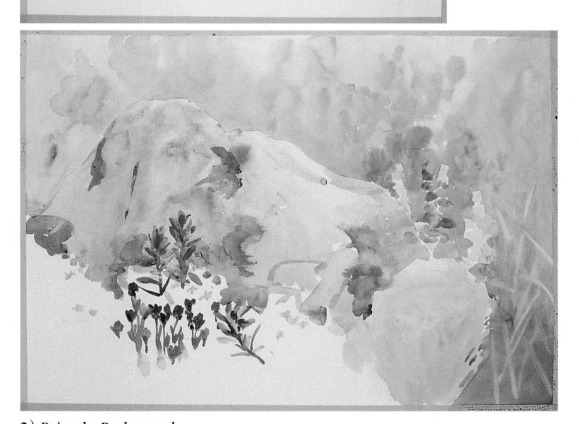

3) *Paint the Background*

After the paint is dry on the rock, paint very wet colors in the background, cutting around the rock. Then go back into areas that are still wet and add dabs of reds, lavenders and yellows and allow them to diffuse into one another without a lot of brushwork. The yellow flowers grow in bouquetlike clumps. Paint the crowns with Cadmium Yellow Light, adding a mixture of yellow-green below for the foliage, and continue to add a variety of green values all the way down to the lower right. While that area is still wet, quickly clean your brush, squeezing most of the water out with a paper towel. Use the chisel-like bottom of the brush in a sweeping motion to lift out the wet pigment on the lower right. Clean and wipe your brush dry before each brushstroke so that the brush acts like a thirsty sponge. You cannot lift out acrylic pigment when it's dry—you can lift it out only when it's wet. Add purplish blossoms in front of the Indian Paintbrush.

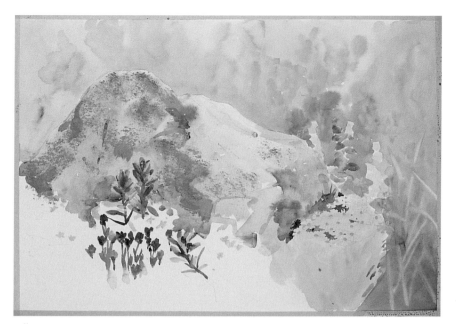

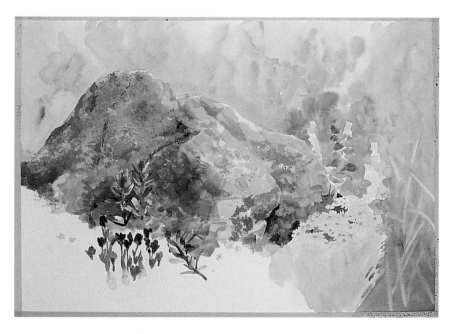

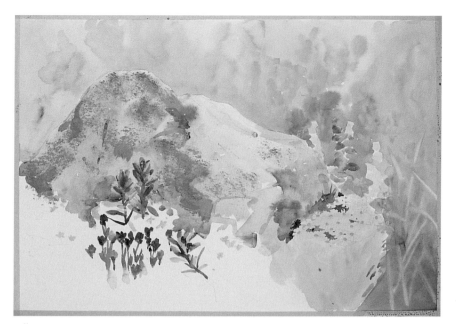

4) *Define Shapes With Pencil and Brush*

It helps to draw tiny circles for the centers of the yellow daisylike flowers and then draw the flower petals around the centers. Dot in Cadmium Yellow Medium for the centers and paint warm greens in some of the negative areas between the blossoms and around the edges. Soap the bristles of a medium round-tip brush before dipping it into the masking fluid to paint over the flowers and plants. Wash the brush thoroughly while the mask is drying. Now you can paint and sponge on colors behind the flower without having to cut around it.

Make several mixtures of pastel colors on your palette and with a small damp sponge dip into one mixture at a time, "sponging" the colors onto the rock and over the masked area.

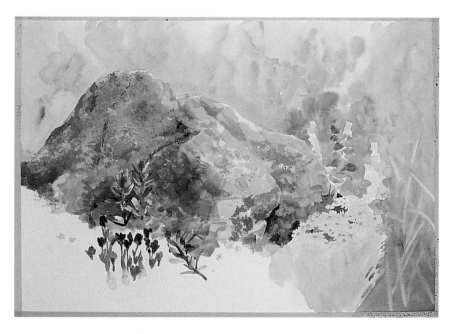

5) *Alternate Transparent and Opaque Pigment*

With a watery mixture of Phthalo Blue, Phthalo Green, Alizarin Crimson and Payne's Gray (or black), glaze over the masked area on the sage-like plant. Tint the same mixture by adding white and paint opaquely over the darker areas. Apply a variety of glazes to the rock, allowing some of the underpainting to show. Alternate between painting with glazes, sponging and painting opaquely. When the area is thoroughly dry, remove the mask.

Prepare a rigger brush with soap and mask the grasses in the background. Use your whole arm to apply the mask in circular sweeping strokes.

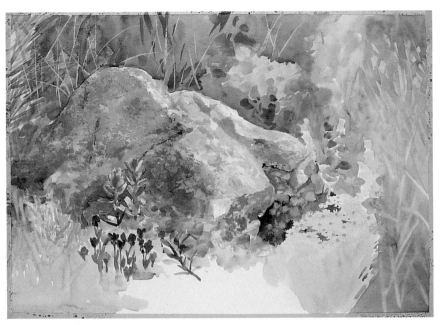

★ tip
**Removing Dry
Masking Fluid**
To remove a mask use a
hardened rubber cement-
like eraser that is made
specifically for this purpose.
The mask can also be
removed by rubbing it off
with your fingers.

6) Apply a Second Wash

With darker values of greens, browns and blues, paint the grassy area again using crisscross strokes over the masked grasses: Cut around the yellow foliage, bring color into the left foreground and go back into wet areas to add more colors for interest. While that area dries, continue to make changes to the rock, adding and defining the lichen, cracks and crevasses.

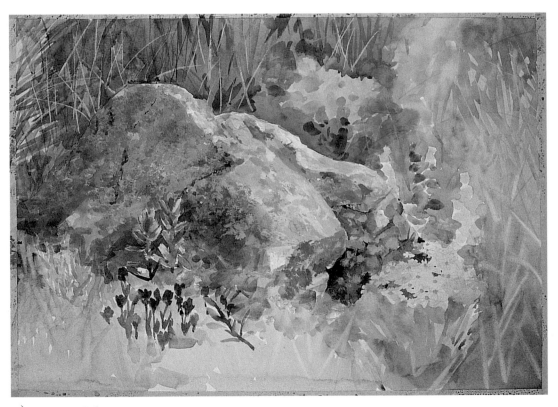

7) Repeat Colors

Mix a combination of Phthalo Blue and Phthalo Green; paint the last white area in the foreground with this mixture. This repeats the colors of the sagelike plant and rock, bringing more blue into a predominantly green painting.

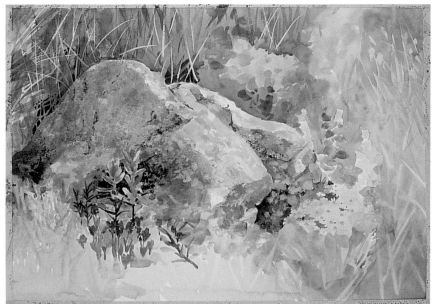

8) *Use Negative Painting*

When the background is dry, remove the mask. To the left and above the rock, begin painting negative diamondlike shapes between the grasses that define the edge of the rock. Glaze over a few of the grasses with a bright green, and also add the same green around the purple flowers in the foreground. While I paint I continually think dark versus light, warm/cool, transparent/opaque, rather than "rock" or "grass." At this stage you are free to hop around the painting, making adjustments and getting lost in the nonshapes of negative painting while thoroughly enjoying the process.

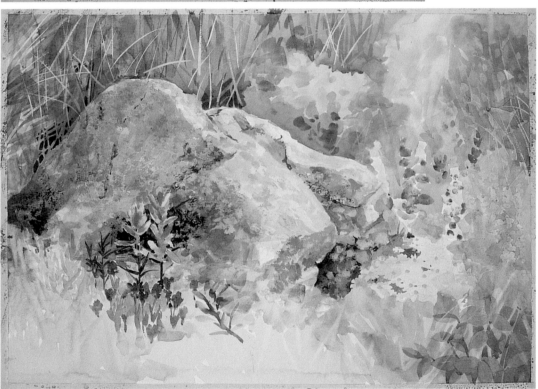

9) *Add Shapes and Colors*

The painting needs more yellow in the upper left. Rather than creating another clump of yellow flowers in a too obvious triangle, glaze over the grasses in a few areas to accomplish what the painting needs.

Mask the bluish plant on the right, dotting it in vertical rows, remembering that not everything has to be round. While that dries draw and then paint green leaves on the lower right.

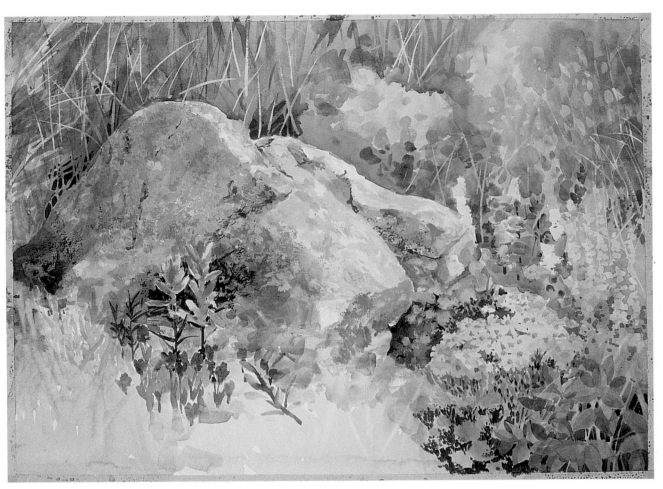

10) *Utilize Negative and Positive Space*

The leaves are more interestingly defined by painting the negative shapes between them and adding different combinations of greens to the leaves as well as the shadow areas. A darker blue over the upright foliage will give contrast when the mask is removed. The yellow plants are extended down into the foreground by creating new blossoms in the yellow-green area. Don't do this by painting new blossoms, but by painting negatively around what will become the blossoms.

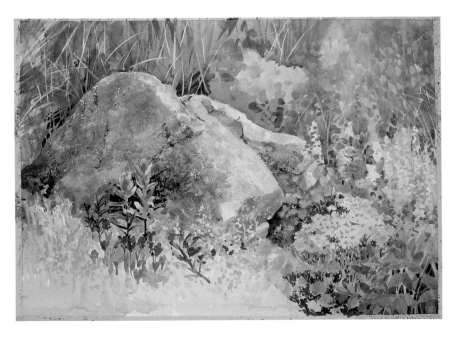

11) *Use More Negative and Positive spaces*

Mix an opaque blue/lavender/gray and dab and dot color on the left. Then use a rigger brush to stroke in light grasses on the bottom left in crisscross strokes to be painted negatively in the next step.

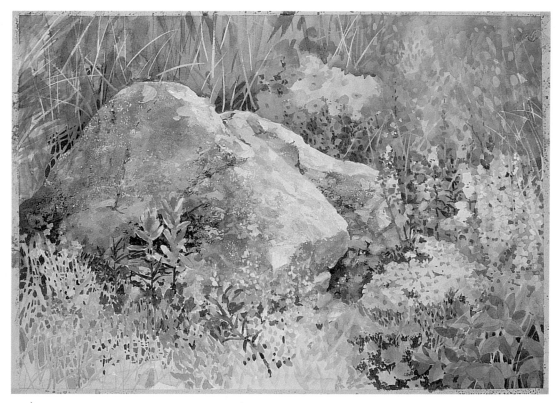

12) *Add Still More Texture*

Using transparent colors, paint the negative areas between the foreground grasses and bring opaque green grasses over the rock.

Carefully spatter white paint on the rock with a toothbrush. Mix a thick warm white, apply it with a palette knife to the sunny side of the rock and repeat the process using a cooler blue/white on the shadow side of the rock. This makes another kind of texture for the rock. More glazes are added over some of the thickly painted areas when they are thoroughly dry.

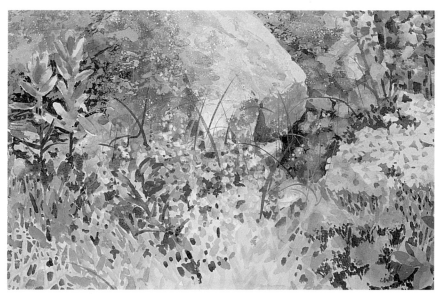

Detail

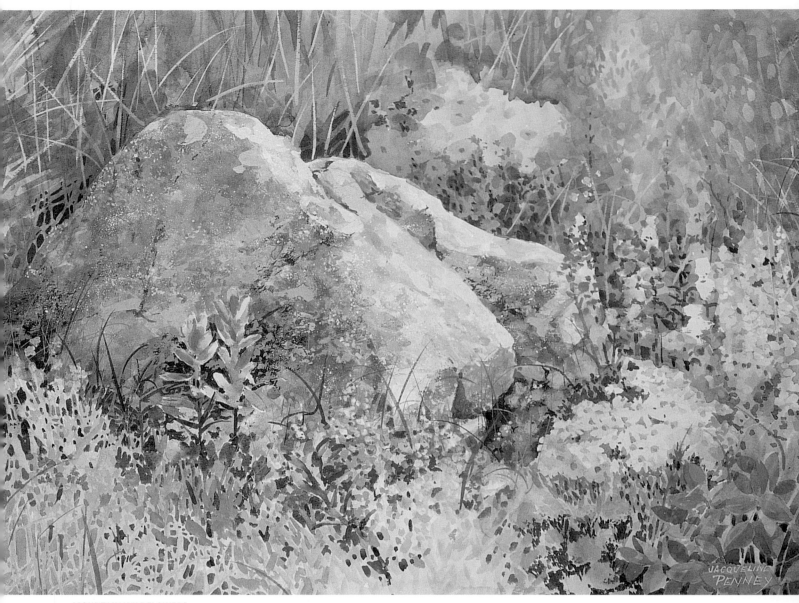

MOUNTAIN WILDFLOWERS
15" x 21" (39cm x 53cm), acrylic on illustration board

"SPRUCE TREES AND FERNS"
ON GESSOBORD

i like to create my own environment in my paintings and many times I use photo subjects from very different areas and combine them into a pleasing composition. They may be geographically different but they go together such as spruce trees and ferns. I recall taking photos of the ferns out west and the spruce trees in Maine.

I used print film to take photos of the ferns and spruce trees. Because I wanted to project the intricate ferns on tracing paper to hasten the process, I tried something different. I put the photo on the floor and took a picture of it using slide film. I did this with several photos and used up the roll of film, and now I have more choices for future paintings.

For this demonstration I use Ampersand Gessobord, which is thin Masonite primed with a smooth coat of gesso that can be purchased from an art supply store. If you prefer, you can make your own painting panels with un-tempered Masonite purchased at a lumber store. Apply two coats of gesso using a fine paint roller, and sand between coats.

Many times we see images that capture our attention, such as spruce trees and ferns. We decide to paint them, rarely giving the background any thought. I suggest that you try painting in reverse. The background is made up of a crosshatching of totally undecipherable branches, trees and whatnot. The watercolor technique of applying variations of wet pigment on a level ground and covering it with crumpled plastic wrap creates a perfect textural surface for the background and foreground.

Use a tracing paper overlay to draw the intricate designs and patterns of the trees and ferns. Take advantage of photographs and slides to project the images on the tracing paper and then transfer them to the prepared ground. Transfer paper is available in black, white and several other colors so that the image can be transferred to any surface.

Almost all of this demonstration is painted negatively. After the drawing is transferred to the board, almost everything that isn't the subject is painted with clear glazes. The only white pigment mixed or applied is in the final stages of the painting. The warm glazes of watered-down pigment, with a little matte medium added, are painted in between the trees and branches, making them seem to pop out. The intricate texture remains on the tree and the background and is not concealed by the light glazes.

(See *Portrait of a Lily* in chapter 2 on pages 36-37.)

tip

Another plus to this technique of painting on Gessobord is that it allows you to frame it without glass or Plexiglas. The finished painting is given a protective coat of matte medium and can be gently washed if necessary. It can be attached to a textured background to allow space between the image and the frame, or placed within a frame. A creative framer can enhance your works of art.

1) *Use A Watercolor Technique*

For this demonstration I am using Ampersand Gessobord that has been prepared with a smooth gesso surface. Add a lot of water to your color mixtures for this technique. (See *Portrait of a Lily* in chapter 2 on pages 36-37.) Brush water on the Gessobord and then either brush on or spatter the color mixtures onto the wet board. The colors will blend and bleed into one another.

Photo by Mike Richter

2) *Apply Plastic Wrap*

Crumple plastic wrap and press it down onto the wet paint.

Photo by Mike Richter

3) *Cover the Surface and Set It Aside*

Continue to apply the plastic wrap to the board while the paint underneath is still wet. To achieve the desired effect, the paint must be allowed to dry under the plastic wrap to create interesting designs and patterns for the underpainting of *Spruce Trees and Ferns*.

Photo by Mike Richter

4) *Remove the Plastic Wrap*

When the plastic wrap is removed, it leaves intricate colored patterns and makes an interesting background for this woodsy scene.

This is the slide I made by taking a photograph of a photo print so that I could project the ferns onto the canvas.

5) *Trace and Retrace Drawing*

Cut the tracing paper to the size of the board leaving enough to wrap around the top so that it can be taped down securely. Tape the two bottom sides to the board and make register marks.

Project the image of the ferns on the tracing paper overlay and trace it carefully with a no. 2 pencil. It is very important not to move the projector or the board because it is almost impossible to register them again.

Refer to a photo print of spruce trees and draw the two large trees in the foreground with their sprouting limbs that reach across the board. When the transfer is completed, make the intricate drawing easier to decipher by using a light-value gray marker to fill in the negative spaces. Slip transfer paper between the tracing paper and the board and trace the trees.

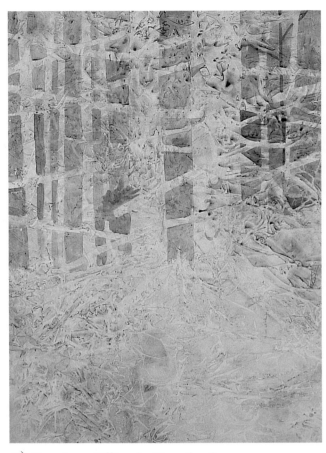

6) *Paint the Negative Spaces*

Paint the negative spaces between the trees with variations of Burnt Sienna, Cobalt Blue, Naphthol Crimson, Cerulean Blue, black and red, and mix the color with matte medium to give it body. One brown tree is painted positively in the right background.

7) *Continue Filling in Negative Spaces*

Each mixture need not be exactly the same and, as a matter of fact, when it isn't it gives the background more interest. Once the negative spaces are painted, the trees pop out. Add some green to the lower branch to show new growth.

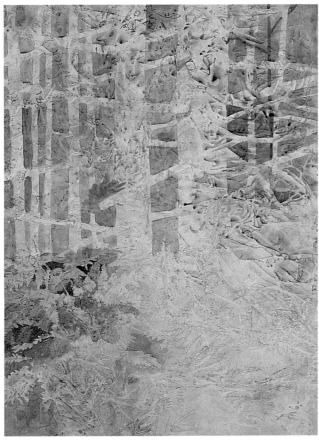
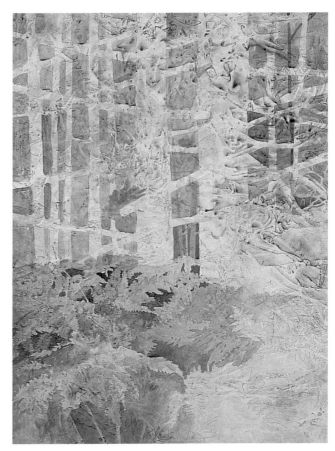

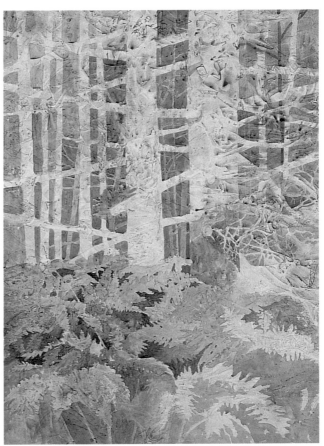

8) *Trace the Ferns and Add Color*

Trace the ferns using the transfer paper. Brighten the fern area using several combinations of yellow/greens. Play with warm and cool color combinations for the negative spaces until the ferns become more visible.

9) *Continue Painting Ferns*

Continue painting positive ferns and negative shapes around them, gradually darkening the value in some places to create depth. Draw more trees in the background using a regular pencil, or a white chalk pencil if the area is dark. Paint the negative space to bring the ferns out.

10) *Use White Chalk Pencil*

Add more ferns as before. In some areas of the painting it is difficult to see the pencil lines. I suggest using a white chalk pencil to draw in the dark areas, making it easier to see. Navigate back and forth from painting the distant trees to identifying and painting the ferns. This is a good way to balance the colors and values. Most of the background is a warm mixture made with several variations of the following colors: Cobalt Blue, Naphthol Crimson, Cadmium Red, Burnt Sienna, Raw Sienna and Yellow Ochre. Add some green behind a few of the trees on the left to balance the predominance of the green ferns.

Using light glazes of Yellow Ochre, Raw Sienna and Burnt Sienna, paint the lower portion of the large tree. If necessary, retrace the lacy branches that are in front of the tree and paint the negative spaces with the same mixture. In the area to the right of the tree use a light blue/gray to fill in the tiny negative areas that create the positive delicate branches.

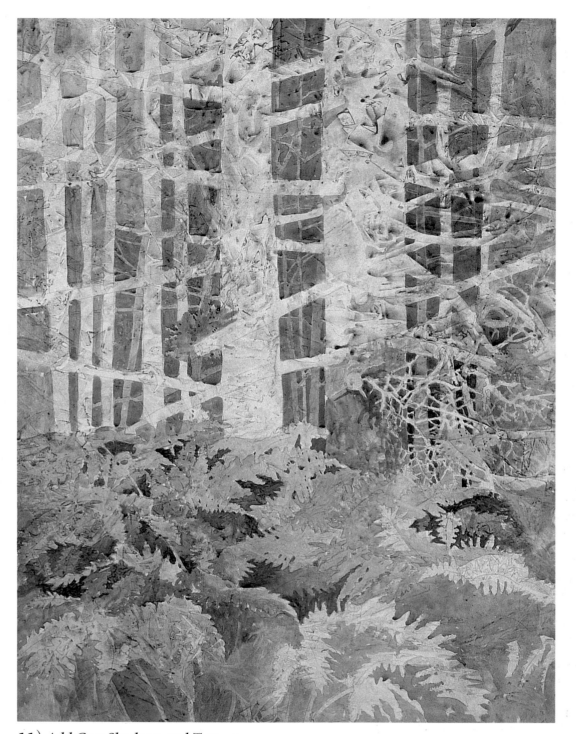

11) *Add Cast Shadows and Texture*

Add Phthalo Blue and a little Naphthol Crimson to your warm mixture to create the cast shadows of the delicate branches and new growth from the branch stump. Make small vertical dashes over the glaze to add texture to the tree trunk. In the area to the right, continue to paint the negative shapes with a light blue/gray, bringing the gnarled branches into focus.

Negatively paint and bring the trunks of the distant trees on the right down into the gnarled branches and down into the ferns. Add more new green growth to the lower branches on the right.

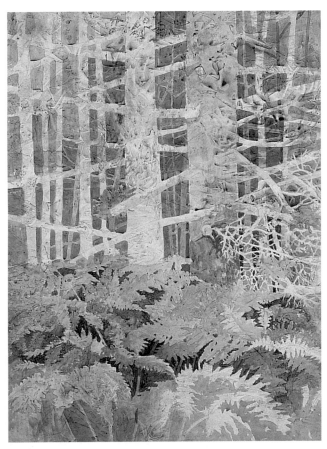

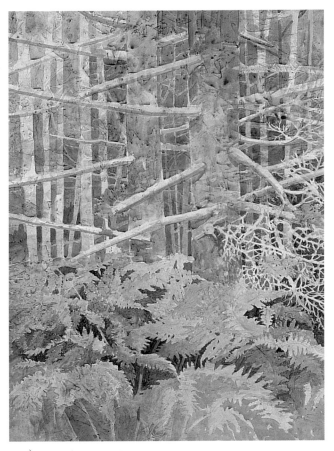

12) *Add Warm Glazes on Large Tree*

The two large trees fight for prominence and are in the middle of the composition. Use pale glazes of Yellow Ochre, Raw Sienna and Burnt Sienna on the larger tree on the right. Add darker and cooler greens to the ferns on the right.

13) *Introduce White Paint*

Use white pigment for the first time to paint more gnarled branches. Add another tree in the right background. Use darker glazes on the large tree to deepen the warm color.

14) *Add Cast Shadows on the Tree*

Mix Burnt Sienna, Cobalt Blue and red to make a medium-dark mixture for the cast shadows under the branches and the cropped limb stumps. To balance the colors, bring a dark green into the background behind the trees, indicating distant foliage. Add cast shadows on some of the branches. Add positive highlights by mixing white with Yellow Ochre to paint light areas on the tree, stumps and some of the branches. Mix a light blue and add touches here and there on the tree, in the background and on the lower right ferns. To give weight to the painting, paint positive and negative dark areas on the lower stems and in the background. This gives the trees and shrubs a feeling of being firmly grounded.

Use a large, approximately 4" (10cm) sponge applicator to apply one even coat of matte medium to the finished painting. Follow the manufacturer's directions. This protects the delicate glazes; the painting can be gently washed and dried when necessary.

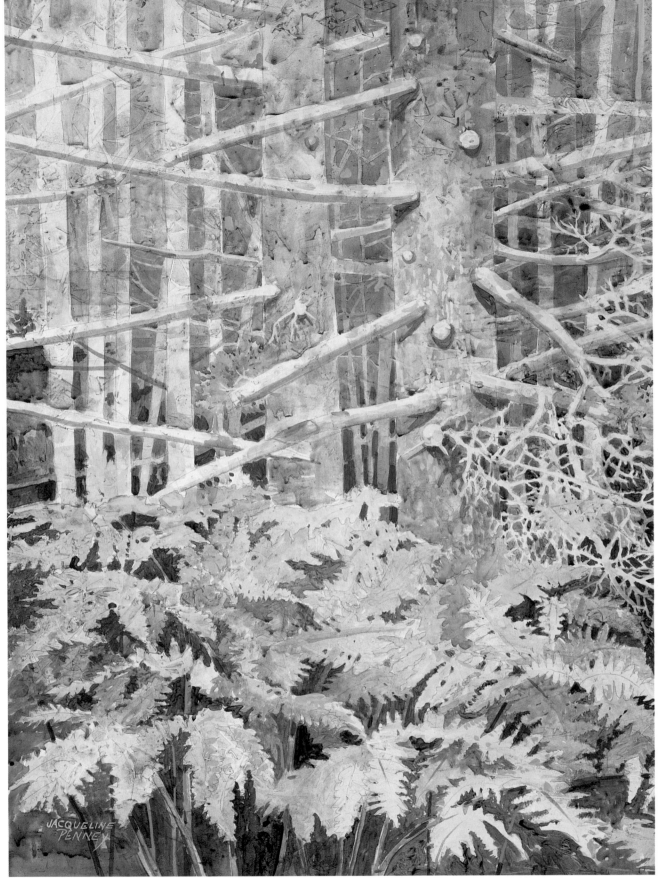

This is a good illustration of how warm colors come forward and cool colors recede. The two large trees fought for dominance before one was glazed with warm hues. When the large tree was painted in warm colors it pushed the cool tree on the left farther back. It also connected the top and bottom of the painting. The lacelike ferns are repeated in the lacy gnarled branches flowing upward on the right side of the painting. Nature is rarely symmetrical, offering incredible diversity for the artistic eye.

SPRUCE TREES AND FERNS
18" x 24" (46cm x 61cm), acrylic on gessobord, collection of the artist

"MIST IN MOTION"

ON RICE PAPER & LUAN BOARD

INSPIRATION

i had a dream about seagulls. They were flying effortlessly, yet each slight movement of their wings left afterimages as if captured by multiple exposures on film. The atmosphere that held them aloft was also moving, almost as if the invisible air was visible. The dream became my muse, and my creative impulse was to express it in my three-dimensional world, namely on canvas.

CREATIVITY AND EXPERIMENTATION

I had been saving a large piece of tissue-paper-thin textured rice paper that was given to me by a friend and decided it was time to put it to use. I had recently begun to paint with acrylics and was intrigued and excited by its vast potential for creativity and experimentation. I remember clearly the day I decided to paint my dream image. In those days I painted in the basement when the kids were off at school, the washing machine was loaded and chugging along in the other room and the radio was playing lovely classical music.

I began painting a soft bluish-gray background on a newly stretched 40" x 40" (102cm x 102cm) canvas. Because the paint dried so quickly I was able to keep painting. I used blackboard chalk to sketch a large seagull with

wings outstretched and webbed feet ready to land in the water that seemed to be one with the sky.

I painted the seagull using photo references, added a few smaller gulls in the distance and made adjustments to the background. I used matte medium to affix the wispy rice paper to the painting and it made the painting look very milky. My husband feared I had ruined the painting by covering it over with "that white stuff."

TRUST THE CREATIVE PROCESS

The next morning I went to my basement studio, thinking the worst, and was surprised by what I saw. There on my easel was my dream come to life. The milky, opaque color was gone. The rice paper had given the painting the atmospheric movement I saw in my dream. I took the painting to a local gallery that represented me, and that evening I received a call from the owner telling me that my painting had sold.

MIST IN MOTION

I will illustrate the rice paper technique on Luan board rather than on canvas because I have never tried it on Luan before, and that in itself stimulates me to go to my easel and give it a try. I love to play and experiment, and I have

1) Sketch in Proportion

The sketch is now in the same proportion as the painting surface. The diagonal pencil line extends from the upper left corner to the lower right corner.

2) Create a Grid

Because the sketch is not a standard size, it is not an easy task to calculate the grid measurements with a ruler. An easier way is to fold the sketch into sixteenths and use the fold lines as a guide.

nothing to lose but time. I decided long ago that the process, or losing time, is more important than the product or end result.

PREPARATION

Choose a photograph of a sailboat and a seagull and make copies of both on a copy machine, adjusting the size of the images to create a relatively small value sketch, approximately 6" x 8" (15cm x 20cm).

COMPOSITION

Taping the copy of the sailboat to a window or glass door makes tracing easier. Move the image of the seagull underneath the image of the sailboat to decide where to place it. Trace the seagull on the photocopy of the sailboat to make an interesting composition.

SHAPES

The large white sails and predominantly white gull are the major subjects of the composition; to make them easier to see, use a light gray marker to designate everything that isn't white. Then use a marker that is one or two shades darker to introduce a third value.

✱ *scaling*

In this demonstration, the pre-cut Luan board is 23" x 30½" (58cm x 77cm), not a standard size. An easy way to figure out the proportional calculation of the sketch in relation to the large board is to draw a diagonal line from one corner of the Luan board to the other. Place the sketch in the upper left corner and decide what you want to include in the sketch by moving it around. You are able to see the impression of the edge of the board underneath the sketch. Mark the edge or edges to be removed; draw a diagonal line through its corners matching the diagonal on the large format; use a ruler to mark the small rectangle, and cut off the edges that are no longer needed.

CUT
THESE
EDGES

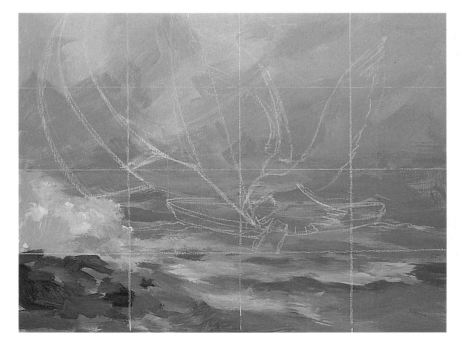

3) *Underpaint*

The misty background is really a backdrop for the sailboat and gull and requires no accurate horizon line. Use Cobalt Blue, Ultramarine Blue and Phthalo Blue, Yellow Ochre, Burnt Sienna, Payne's Gray and white. This limited palette enables you to create a wide variety of secondary hues and values.

To duplicate the grid lines on the board to correspond with the sketch without having to measure with a ruler, use a strip of paper to measure the length of the board, fold the paper in half and then in quarters. Mark the folds. Place the paper back on the board and mark along the top and on the bottom using chalk. Repeat the same process for the vertical measurements. Then connect the lines using chalk. Refer to the sketch and draw the sailboat and gull, matching where they are in the grid lines.

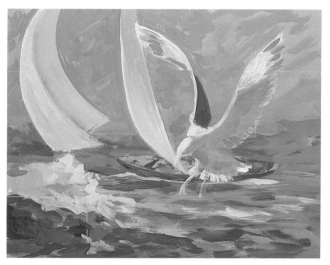

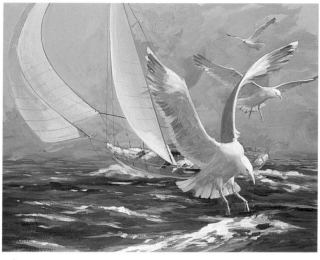

4) Paint

The painting is an accurate duplicate of the sketch. I like the way the gull's wings interact with the sails, the opposing curves creating energy, but something is wrong. Seagulls land into the wind.

5) Make Big Changes

I trace the seagull that I painted on the rice paper and reverse its direction by turning the tracing over and retracing it onto the board using white transfer paper. I repaint the gull right over the first gull and paint background colors over the remainder of first gull. I add two more seagulls, causing more movement and creating tension between the boat and the gulls, both heading in opposite directions, creating an explosion effect.

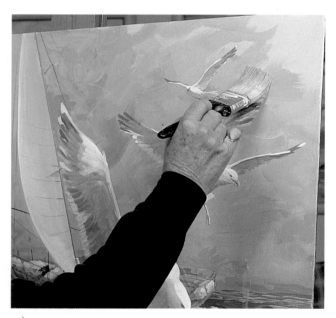

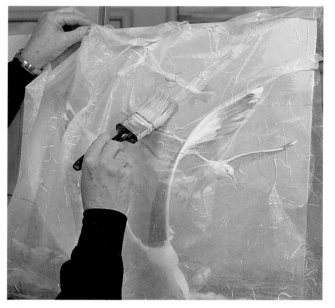

6) Create the Illusion

Apply matte medium directly onto the righthand side of the painting with a large brush and immediately go to the next step.

Photo by Mike Richter

7) Affix the Rice Paper

Lay the tissue-thin rice paper over the damp matte medium, allowing it to wrinkle and crease. Gently brush more matte medium on the rice paper, affixing and sealing it permanently to the painting. Arranging the rice paper quickly to overlap itself while you brush it into place enhances the illusion of movement. It will look a little milky but will dry clear.

Photo by Mike Richter

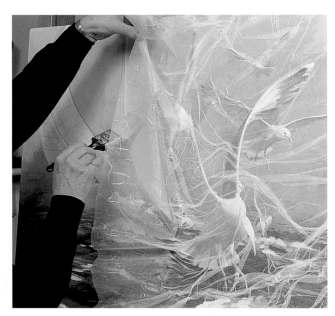

8) *Continue the Process*

It is important to coat the painting with matte medium before applying the rice paper and then to apply more medium over the rice paper so that it adheres firmly to the board. This can be done in stages so the medium will always be damp.

Photo by Mike Richter

MIST IN MOTION
23" x 30½" (58cm x 77cm), acrylic and rice paper on luan board, collection of the artist

"GRAND WALKWAY" ON CANVAS

i **EXPLORING DIFFERENT TOOLS AND TECHNIQUES**
constantly explore different tools and techniques with a
"what have I got to lose?" attitude. Acrylic paints give me
the option to paint over something if it doesn't work.
Some watercolorists use masking fluid to preserve the
white of the paper. I used it to create some of the white
pebbles on the *Rocky Beach* painting (page 69) and to pre-
serve a flower painted on illustration board so that I didn't
have to paint around it in *Mountain Wildflowers* (page 105).

1) *Block In*

I have no set way to begin a painting, but I do spend a lot of
time thinking about what technique I will use and how I will
begin allowing the subject matter to influence my decision. For
this painting we will use very watered-down pigment. Block in
the landscape with a large brush over a lightly drawn charcoal
sketch of the composition. Set the canvas upright on your
easel so the paint runs and drips. This stimulates a feeling of
spontaneity and you can express yourself with abandon. You
do not to have to wait for the paint to dry to make corrections.

2) *Use Modeling Paste*

With charcoal, lightly sketch in where the large foreground
trees are to be placed. Then with a palette knife apply small
globs of modeling paste to the area where the waves break on
the shore. To create tiny bits of texture to the ocean area,
stomp the palette knife down several times on the palette to
distribute a small, even amount of paste on the bottom of the
knife. Using the whole underside of the palette knife, barely
touch it to the canvas and stroke very gently across the area,
allowing minute fragments of paste to adhere to the surface.
Later, when the paste is dry, scumble white paint lightly over
the tiny bumps to create glistening waves.

3) Paint the Sky

Wipe away the charcoal drawing of the trees and paint the sky without having to paint around anything. Make the sky and clouds warm. Mix several combinations of violet, orange, Cadmium Red, Phthalo Blue, Cerulean Blue and Cobalt Blue, and use a large bristle brush to blend the subtle colors on the canvas. Use the same hues and tints for the distant land, adding a little green to the original combination of colors.

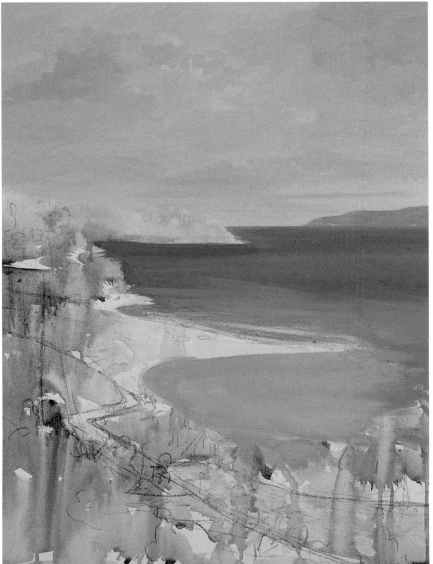

4) Paint the Water

To make the horizon perfectly level, measure down on both sides of the canvas and lightly connect the marks with pencil. The dark, distant water is a mixture of Ultramarine Blue, Cadmium Orange, black and lightly tinted with white. Place the bottom of the yardstick on the horizon line to use as a guide as you brush in the horizon line. As you move downward, no longer using the ruler, add more Phthalo Blue and white, brushing it in, back and forth. The tropical water becomes turquoise in the shallow areas. Add Phthalo Green and more white, constantly brushing and blending each new addition of color until there is a gradual transition of value and color.

5) Add the Land

Stipple in the hillsides with myriad tinted colors and paint the large sandbank with variations of ochres, tans and browns.

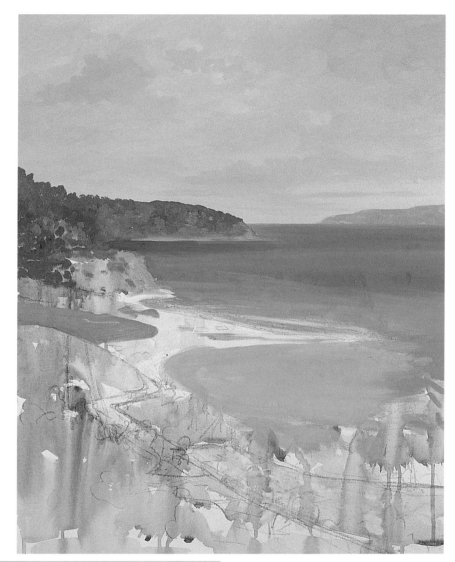

6) Scumble and Add Distant Details

Using the flat of the palette knife as you did in step 2, dip the flat part of the blade in white paint and dab it on your palette several times to distribute an even amount of paint on the bottom. Then, holding the knife with the flat side to the canvas, very gently scumble the white paint over the little bumps of modeling paste in the ocean, creating tiny whitecaps. Apply more white pigment over the breaking waves near the shore. With a small round-tip brush, paint a few white houses, use pointillistic dabs for the foliage and add more warm colors to the rocky banks.

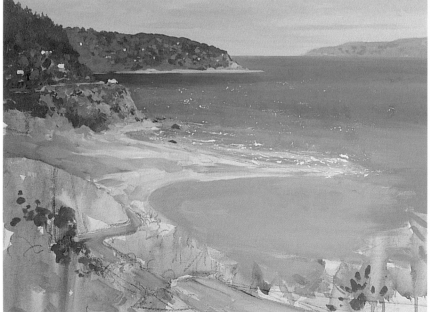

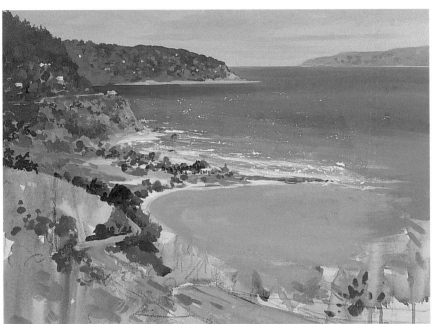

7) *Define*

Use the yardstick to steady your rigger brush to paint the distant beaches, and put more white on the breaking waves using a small round brush. Define the tiny houses, trees and foliage on the spit of land. You can go back at any time to make corrections to the sky, water and land because you have not added any foreground trees to paint around. This medium gives you so much freedom. You can repaint whole areas of the background without worrying how long it will take to dry, make corrections and even wipe out mistakes quickly without disturbing the painting underneath.

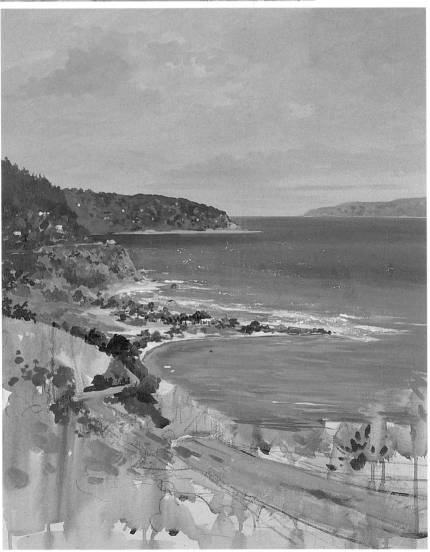

8) *Create the Lagoon*

Use a drybrush technique to blend the subtle variations of blue-green color in the lagoon. Add purple shadows to the left of the tiny trees, and make the boats with two dashes of white.

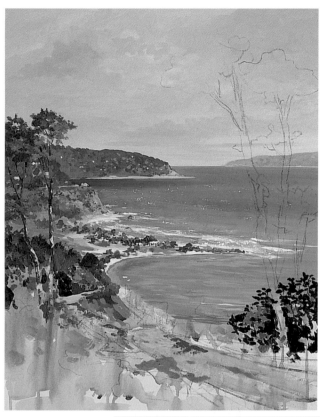

9) *Add Trees and Foliage*

Redraw the trees with charcoal and stipple their foliage with several variations of green, connecting the branches to the main trunk with a small round brush. Use a variety of tints and horizontal brushstrokes on the trunk because it breaks up the accentuated height. Next paint the foliage that will actually be behind the trees on the right. Add lavender-rose cast shadows to the left of the tiny trees below, bringing some of that color into the foreground.

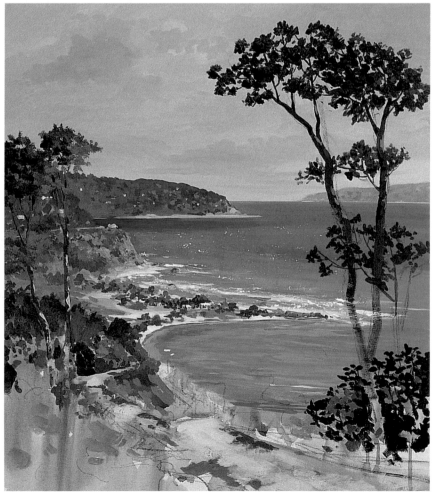

10) *Utilize Overlapping Shapes and Brushstrokes*

Create the illusion of twisting trunks by adding variations of tints, shadows and brushstrokes. The tree overlaps the lacy foliage behind it, and little chips of sky peek through the leaves.

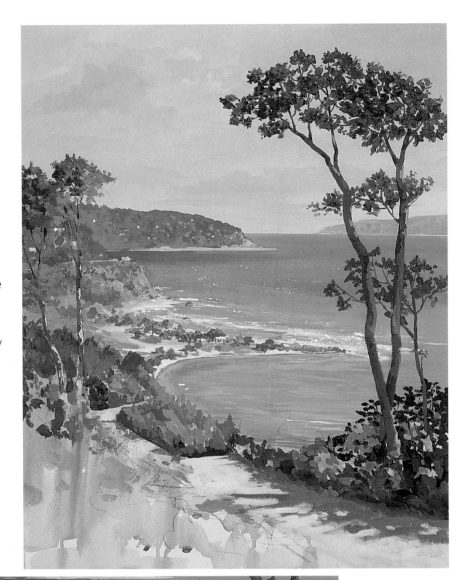

11) *Play With Color*

Wipe away the charcoal marks and continue "playing" with your colors on the trees and foliage. Lighten the pathway and begin to add the warm rosy cast shadows.

12) *Use the Palette Knife*

Transparent color is brighter when applied over white. Apply patches of white with your palette knife in areas where you want to place flowers when the thickly painted area is dry.

13) *Glaze and Draw*

Glaze over the white areas with warm colors that enhance the brilliance of the flowers, and apply opaque colors as well. Draw the iron fence with charcoal; use a ruler and a rigger brush for the straight parts and a small round brush for the decorative parts of the fence. I never use pure black for anything. I like to mix my dark values using all the dark pigments on my palette. The result is a much more interesting black value.

14) *Paint Negative Shapes*

Add more shadows to the pathway, pencil in tropical leaf shapes and paint negatively around them to preserve their transparent color. I notice a speck of paint in the upper left sky and I mix a similar hue, paint over it and drybrush around the area to blend it into the existing color.

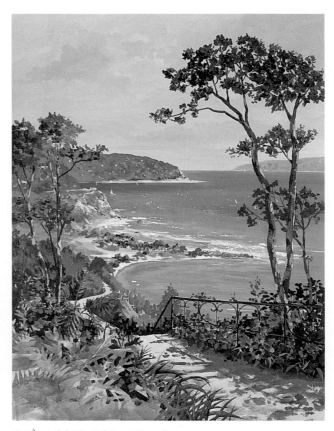

15) *Add More Glazes*

To give the flower shapes more form, paint around them with dark greens. Adjust the color values on the tree trunks and add two more branches to the trees on both sides of the path. The branches reach toward one another and keep the eye from traveling up and out of the picture. Mix a glaze of Phthalo Blue and Phthalo Green and paint horizontal strips across the foliage on the left to give the impression of cast shadows. This also repeats the color of the water and creates a harmonious passage from the land to the water.

16) *Add Finishing Touches*

Wipe away any charcoal smudges left on your canvas and more clearly define areas and make minor changes. Add red rooftops to the houses, define leaves and foliage, create steps going down to the sea in two areas and add another little house near one of the paths. The addition of the very tiny sailboats in the distance draws the viewer even farther into the painting because of their recognizable shapes.

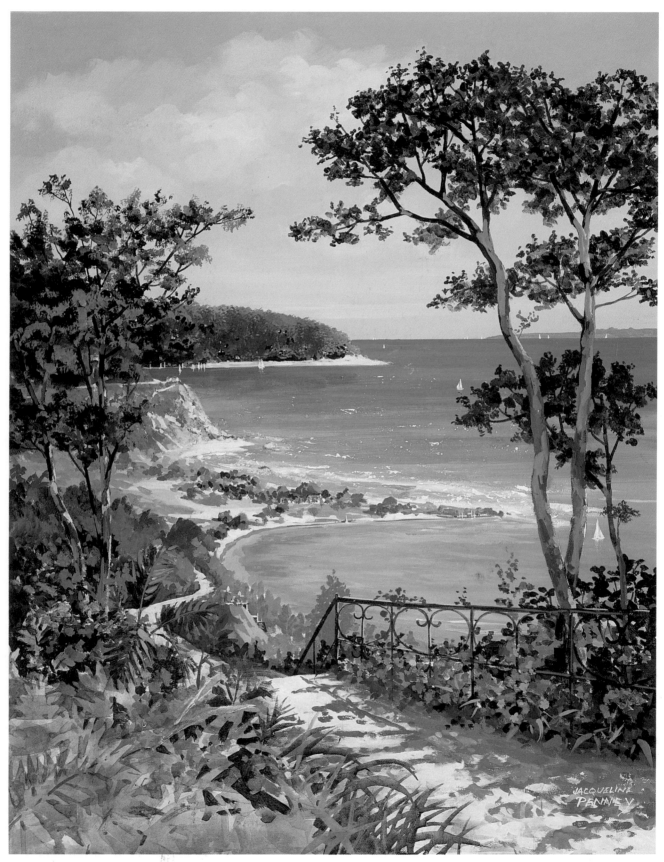

GRAND WALKWAY
22" x 29" (56cm x 71cm), acrylic on canvas, collection of the artist